PIECED
flowers

RUTH B. McDOWELL

C&T PUBLISHING

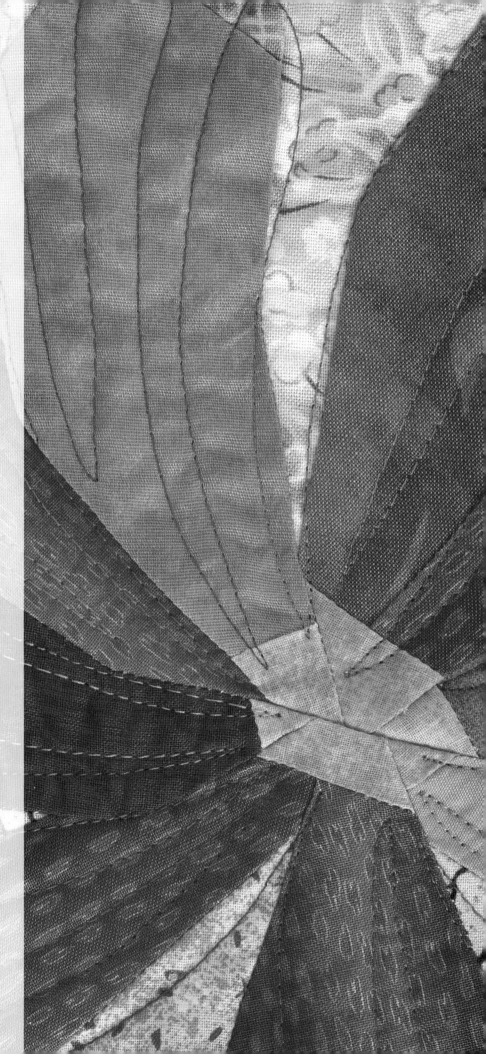

© Copyright 2000 Ruth B. McDowell

Developmental Editor: Barbara Konzak Kuhn
Technical Editor: Sara Kate MacFarland
Cover Design: Aliza Kahn
Book Design: Aliza Kahn
Production Director: Kathy Lee
Editorial Assistant: Brooke Steward
Illustrator: Kandy Pederson © C&T Publishing
Photography: David Caras and Sharon Risedorph

Attention Teachers: C&T Publishing, Inc. encourages
you to use this book as a text for teaching. Contact
us at 800-284-1114 or www.ctpub.com for more
information about the C&T Teachers Program.

We take great care to ensure that the information
included in this book is accurate and presented in
good faith, but no warranty is provided nor results
guaranteed. Since we have no control over the
choice of materials or procedure used, neither the
author nor C&T Publishing, Inc. shall have any lia-
bility to any person or entity with respect to any
loss or damage caused directly or indirectly by the
information contained in this book.

Library of Congress Cataloging-in-Publication Data
McDowell, Ruth B.,
Pieced flowers / Ruth B. McDowell.
 p. cm.
 Includes bibliographical references and index.
 ISBN 1-57120-091-6 (paper trade)
 1. Patchwork--Patterns. 2. Quilting--Patterns.
 3. Flowers in art.
 I. Title.
 TT835 .M39962 2000
 746.46041--dc21
 99-006982

Published by C&T Publishing, Inc.
P.O. Box 1456
Lafayette, California 94549

Printed in Hong Kong
10 9 8 7 6 5 4 3 2

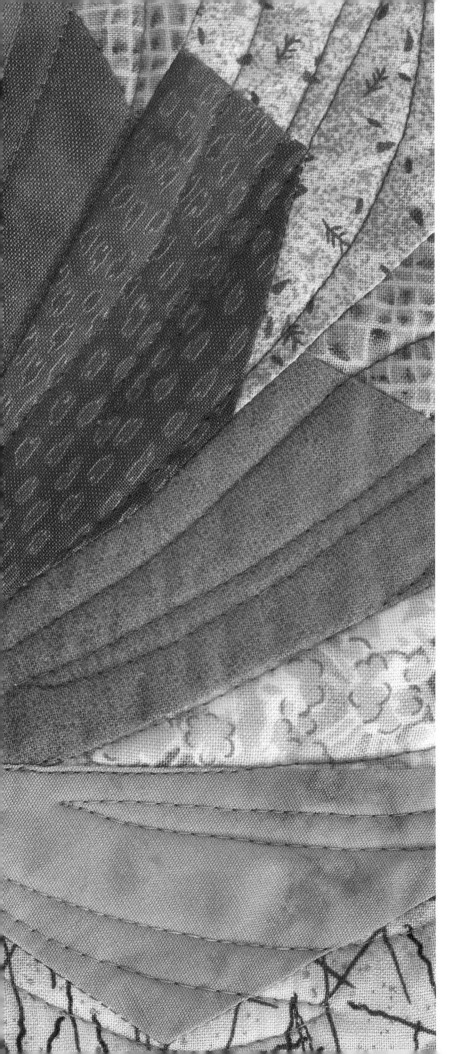

Preface

Flowers are always a source of traditional quilt designs. They are a source for my own designs as well, first as repeated blocks and then as overall designs. In *Pieced Flowers*, I piece designs for ten different flowers. Each flower can be pieced in many different ways, some easier and some more difficult, but each with a different visual character. Some are individual blocks, with few templates, repeated to produce a "traditional" block quilt. Some have multiple blocks, flowers, leaves, buds, and pods. Some blocks are unusual shapes, for example: triangles or pentagons. Some require straight-seam piecing, and others need pieced curves, inset corners, or faced flaps. A few are over-all pieced designs, without blocks, and with each template used only once.

I developed each of the ten flowers in several different styles. Some block designs exploit the underlying geometry of the flower in a graphic way, and some are more "naturalistic" renditions. Other blocks are sketched as geometric quilts and also as more random, pictorial layouts.

I hope you enjoy using these blocks to make your own quilts. You will learn useful ideas to design for piecing. But more importantly, I hope *Pieced Flowers* encourages you to "grasp the nettle" to develop your own designs, choosing your favorite flowers and making original designs and quilts that express your individuality and love of quilting. Good luck.

Contents

Campanula

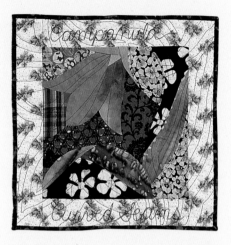

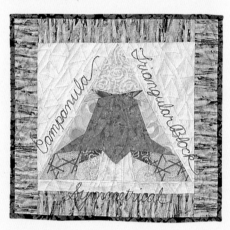

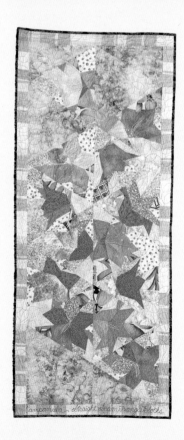

Columbine Cosmos

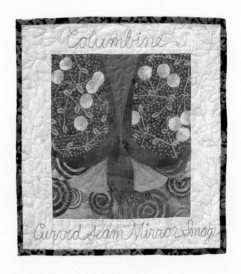

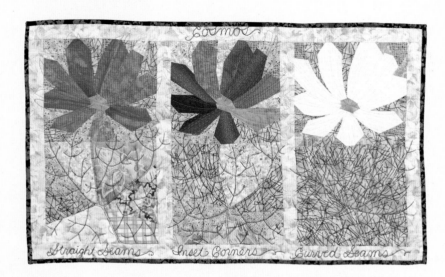

Daisy

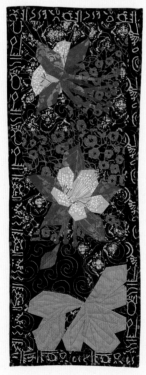

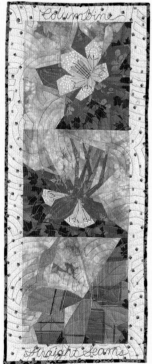

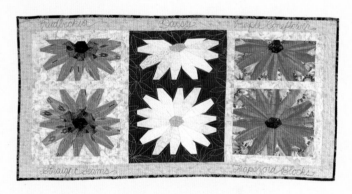

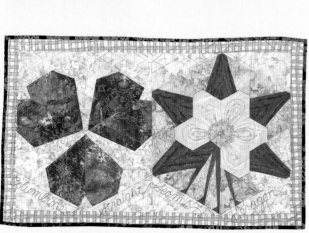

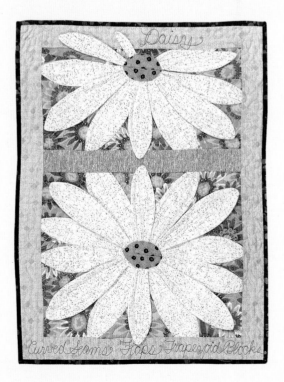

Day Lily

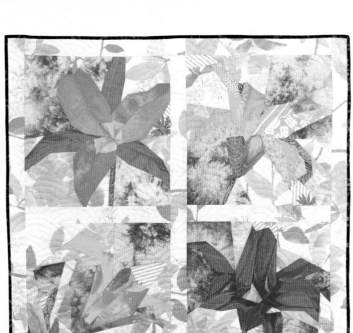

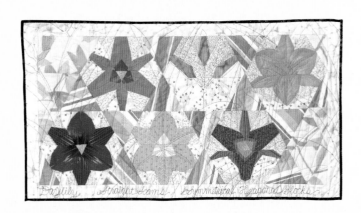

Hollyhock

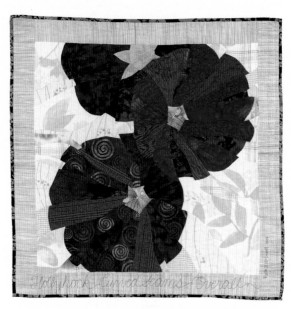

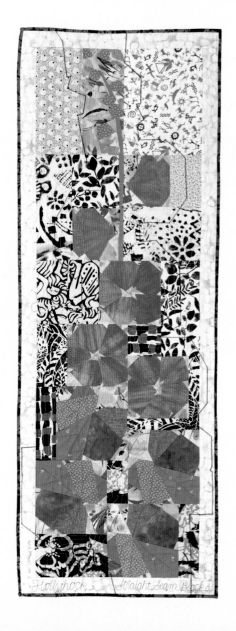

Morning Glory

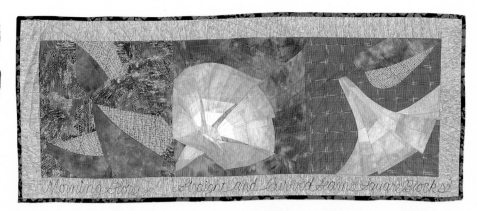

Iris

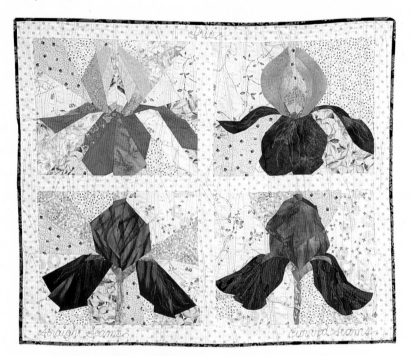

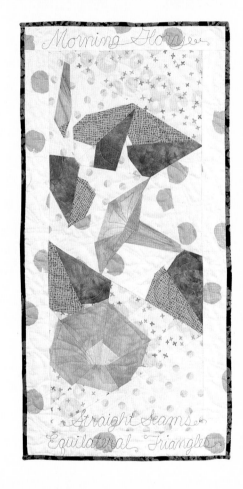

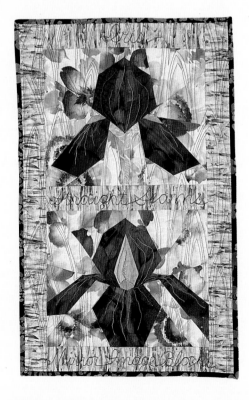

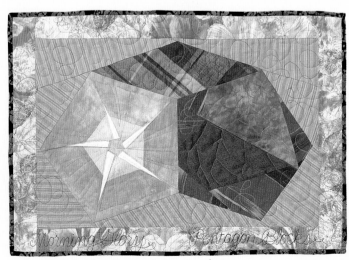

Rose

Sweet Pea

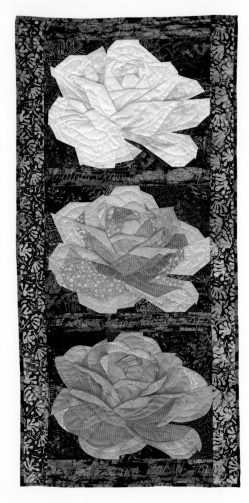

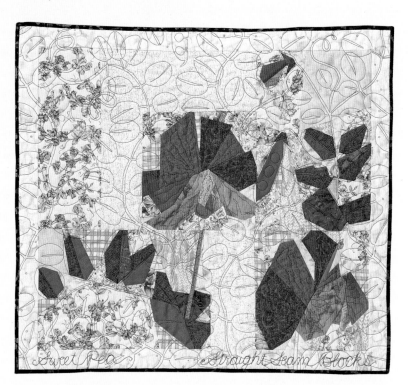

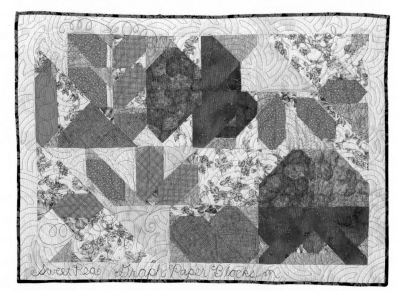

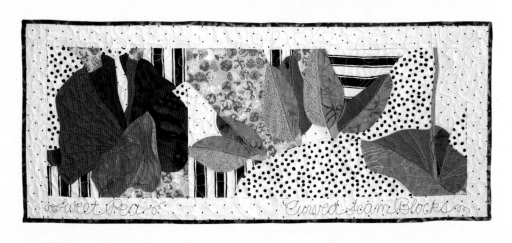

FABRIC SELECTION

In order to show off the piecing designs of the blocks for this book, I limit my fabric choices to more conventional selections than I often make. If I were making non-teaching quilts from these designs, I would certainly be less restrained. Please feel free to choose whatever exuberant fabrics strike your fancy.

One particular place to note in terms of fabric selection is the choice of fabrics used in background pieces. Most students initially try to use the same fabric in all of the background pieces in a quilt block. While this cuts down on the number of decisions to make in sewing the blocks, it tends to produce blocks that look almost as though they are appliquéd. In general, the background of a single fabric is fairly uninteresting as a design element.

Choosing several similar, but different, fabrics for the background pieces within a block often produces a much more interesting design. An alternative would be to choose one very large-scale fabric for the background pieces. Fracturing the large scale of the design by cutting it up for different background pieces can be fascinating.

In some layouts, for example in the Hollyhock quilt made from pieced square blocks and background rectangles, the background pieces in the blocks will be adjacent to the background rectangles. It is not necessary that they match; in fact, it is usually more exciting if they are not the same fabrics.

The Issue of Scale

The issue of scale is one that is always a problem with my students when creating pieced-flower designs. Some often desire to piece the flowers at the same size as found in nature. Yet, when translating an element from nature into a drawing or a quilt, you are not re-creating the flower, but interpreting that image on a flat surface in pen and ink, paint, thread, or fabric. You are making the translation in some particular artistic medium.

When you are working in the medium of pieced quilts, it is important to make the design appropriate to that particular medium. I greatly prefer, therefore, to make the size of the pieces in my flower quilts similar to those found in traditional geometric pieced designs. It is a comfortable scale for the process and the fabric. This means that the flowers in my pieced quilts are often much bigger than they are in the garden. It is often difficult to convince my students to make this leap. After some experimentation, most find they are much more pleased with the result when they match the scale of the fabric pieces to the size of pieces in traditional quilts.

Simplification

When you translate any flower into piecing, you will find that you will have to leave out, or only imply, many details. I often feel that my strongest pieces are the ones that have distilled the essence of the plant, and pruned away the excess. This is a process that takes practice and experimentation. For a more detailed discussion, use my book *Piecing: Expanding the Basics*.

I present several alternative solutions to piecing the many petals of daisies or double roses. I suggest the three-dimensional quality of long-spurred columbine in a number of different ways. And even though it may seem feathery dill-like foliage like that of the cosmos plant defies piecing, it can be implied by a combination of large-angled piecing, careful fabric selection and quilting stitches.

A careful examination of real flowers from which these designs are made will reveal where details have been eliminated. In the hollyhocks and campanulas, the pistils and stamens have been added with embroidery

This particular group of flowers are favorites of mine; they also represent different flower structures (or leaf structures) and different piecing problems.

because they seemed to be necessary to the design. In the columbines, the stamens are implied with pieced, striped fabrics. In other cases, stamens and veins are drawn in with free-motion machine quilting.

Construction

I prefer to piece from templates for a number of reasons:

The appearance of the pieced block and the finished quilt can be greatly enhanced by the careful choice of direction in which the seam allowances are pressed. I press my seam allowances to sculpture the surface of the blocks, pressing the seams under the piece which I want to lift from the surface of the quilt, rather than pressing it toward the darker fabric or in a direction to minimize bulk. For the most part, my seams are pressed under the flower petals, or under the leaf or bud. This lifts the plant away from the background, a process which can be further enhanced by the quilting.

Foundation or paper piecing does not allow for the free choice of seam allowance direction, while template piecing does.

For piecing multiple blocks, template piecing is a much quicker method than paper piecing. I stack cut block pieces and chain piece them through the machine, clip them apart, press the seams, then chain piece the next piece to the previous ones. An experienced machine-piecer might piece eight or ten blocks this way in the time it might take for experienced paper-piecers to piece two.

Template piecing with care and experience can be as accurate as paper piecing. Accuracy is important in the making of templates, cutting the pieces, sewing and pressing. It is very helpful to practice with simple blocks before trying more complex ones. Begin with straight line piecing. Then explore curved seam piecing and

inset corner piecing. Refer to my book, *Piecing: Expanding the Basics*, for practice examples.

Template piecing wastes less fabric than paper piecing. Make templates with whatever method you find works best for you. When I am making multiple copies of a block, I use plastic templates with the 1/4 inch seam allowances included. If I am making one or two copies, I may use freezer paper for templates. Refer to pages 111-112 for more information.

QUILT DESIGNS

I offer quilt design layout options with each of the flowers for inspiration. However, there are no piecing instructions for the layouts. As a guide for basic quilt construction, use the following piecing diagram as an example (Hollyhock blocks page 57). To make this quilt, you will need to piece one bud, two side flower blocks, three face flower blocks and four leaf blocks . Rather than setting the blocks together edge to edge or with sashing, as with a standard quilt, I have put them together with a series of rectangles to make an entire hollyhock plant. The quilt is 50 inches by 16 inches (about 127 by 40 cm). All of the background pieces in the blocks are cut from the same large-scale print.

For those of you who choose a more unique approach, I offer another quilt design meant for an expert piecer, since the final assembly is extremely complicated with numerous partial seams required.

On a large piece of paper, I made an arrangement with five face-flower paper blocks, two side-flower paper blocks, one bud paper block,

and five leaf paper blocks, sliding them around and overlapping them to make a pleasing design. I tweaked them a little to make some of the seamlines match, and "erased" the block edges.

This gradually led to an overall piecing design which I drew out at full size, making certain I had thought through the piecing process for each piece in the overall pattern.

I planned a partial border at the same time. The quilt is about 37 1/2 by 19 inches (95 by 48 cm).

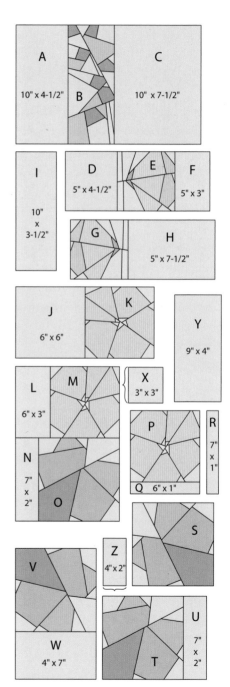

Hollyhock piecing diagram

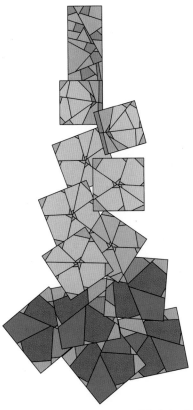

Beginning to develop an overall hollyhock quilt. 1 bud block, 2 side flowers, 5 face flowers, 5 leaves

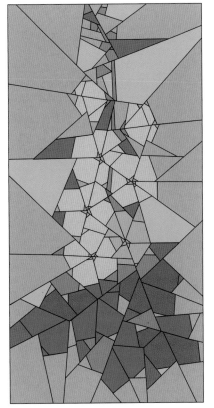

"Erasing" the block edges of the hollyhock quilt

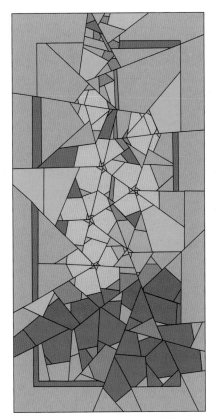

The piecing pattern for the overall hollyhock quilt, including a partial inset border

After piecing the required blocks, sew:
A to B to C
D to E to F
G to H to DEF to I to ABC
J to K
L to M
N to O to LM
P to Q to R to S
T to U
V to W
X and Z are "puzzle pieces".*
*Refer to the Appendix, page 110.
Sew a partial seam (⌣) to join LM to X
Add JK
Add Y
Add PQRS
Join TU and Z with a partial seam (⌣)
Sew VW to TUZ
VZ to NO
Finish partial seam MX to join MOZ to PQS
Finish partial seam TZ to join TU to ZS
Note: Dimensions are finished size. Cut rectangles ½" bigger each way to allow for seam allowances.

On the shiny side of freezer paper, placed over the drawing, I traced all the seamlines with a fine-line permanent marker according to the directions in the freezer paper section (pages 111-112).

Although all seams are still straight lines, piecing this quilt is a much more complex process than the preceding quilt, involving partial seams (puzzle pieces, page 110) in places. With no repeating block elements, fabric selection, cutting and sewing are much slower.

Again, I have added a center detail with embroidery and quilting to the open flowers. There is no piecing diagram or sewing instruction for this quilt. You're on your own!

If you wish to make any of the blocks in a different size than what is given, you can easily figure enlargement percentages with a simple calculation. The measurements must be in decimal format (8 ½ = 8.5), using the following guide:

(Desired dimension of block) ÷ (block pattern dimension)x100
17"(desired size) ÷ 8.5"(size of pattern in book) = 2 x100 = 200%

QUILTING

Careful consideration was given to the design of the quilting for each of the blocks and quilts for this book. I have quilted with machine free-motion (darning foot and dropped feed dogs) without marking the quilting in advance. I am working at getting as adept at drawing with the sewing machine as I am with a pencil.

This is certainly a much easier process when making small pieces rather than full-size quilts. It also suggests to me that I should use a quilt-as-you-go assembly method more often in my bigger pieces. (Hand quilting would work equally well if you prefer that technique.)

I use quilting designs to sculpture the surfaces, add stamens, veins, and details to the blocks, and to draw in additional leaves and stems in some. I encourage you to explore other options as well.

Campanula

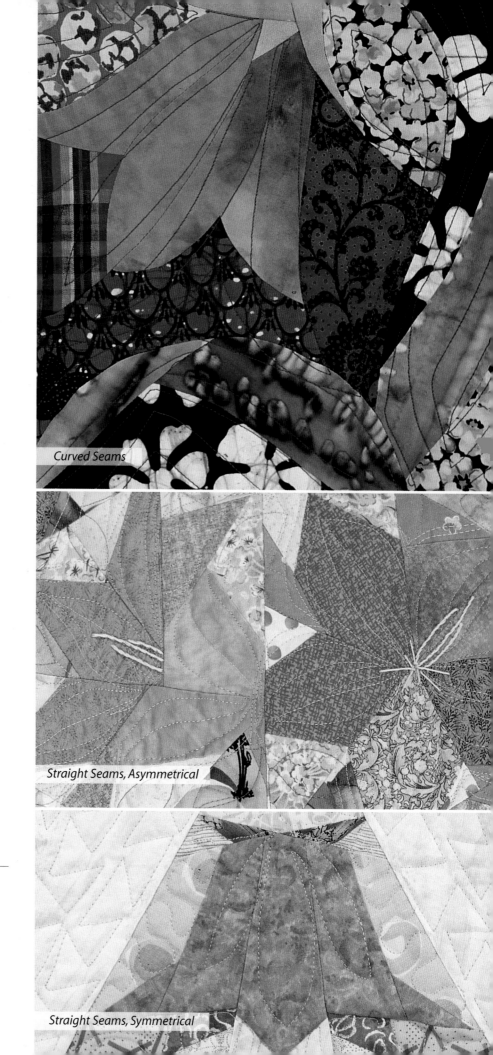

Curved Seams

Straight Seams, Asymmetrical

Straight Seams, Symmetrical

There are many species of campanulas or bellflowers, from tiny alpine wildflowers to stately mainstays of the perennial garden.

Curved Seams

A curved-seam version of Campanula

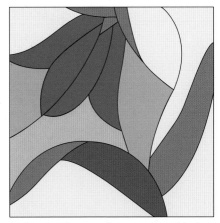

Campanula, curved seams, square block

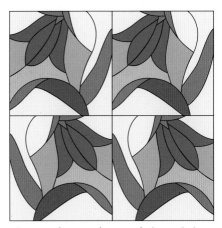

Campanula, curved seams, design variation

A tiny species of Alaskan campanula was my inspiration to create this block. Its gentle curves are time-consuming, but produce a graceful design.

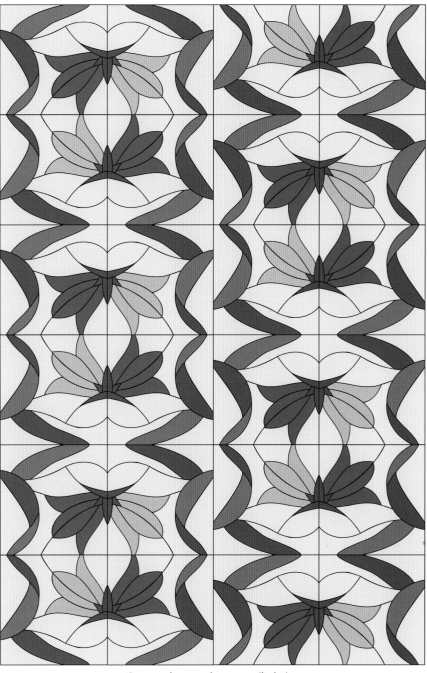

Campanula, curved seams, quilt design

Make the block at least 9 ½ inches on a side (24 cm) for ease of piecing.
Enlarge the pattern 211%.

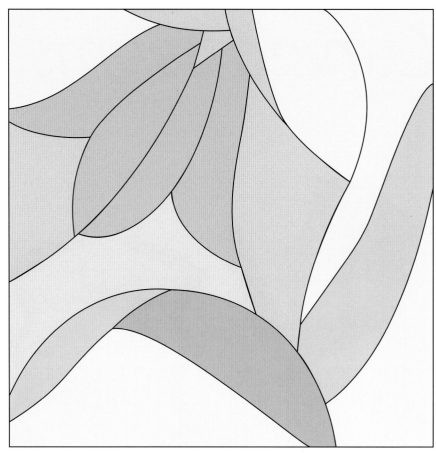

Campanula, curved seams, block pattern

Sew:
 A1 to A2 to A3 to A4
B1 to B2 to B3 to B4 to B5
A to B to C
D1 to D2 to ABC
E1 to E2 to E3 to ABCD
F1 to F2 to F3 to ABCDEF

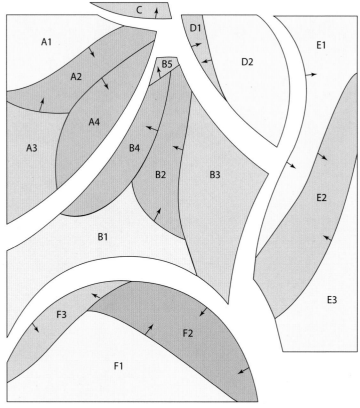

Campanula, curved seams, piecing diagram

Straight Seams

Asymmetrical versions of Campanula

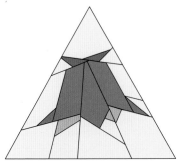

Campanula, straight seams, Flower 1

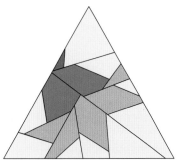

Campanula, straight seams, Flower 2

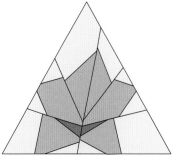

Campanula, straight seams, Flower 3

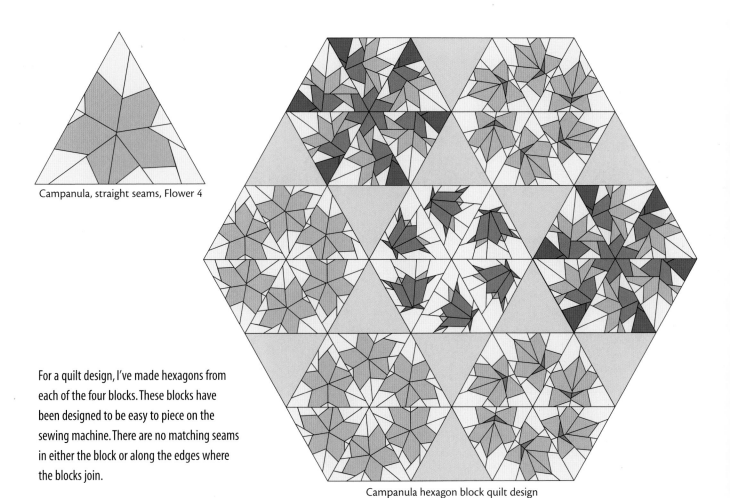

Campanula, straight seams, Flower 4

For a quilt design, I've made hexagons from each of the four blocks. These blocks have been designed to be easy to piece on the sewing machine. There are no matching seams in either the block or along the edges where the blocks join.

Campanula hexagon block quilt design

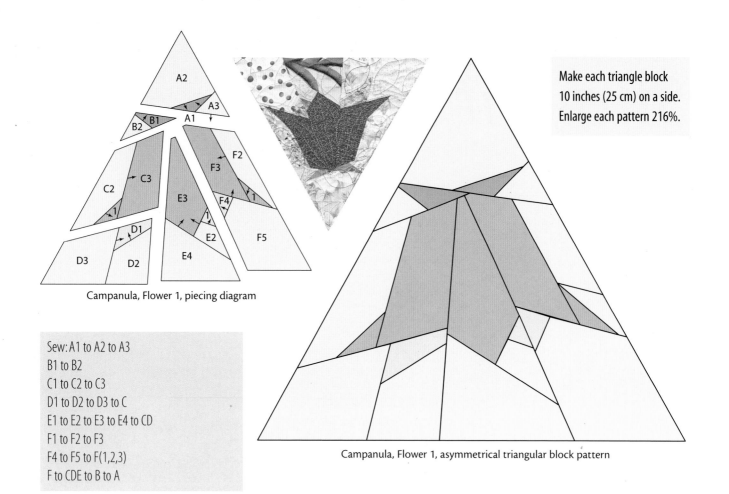

Make each triangle block
10 inches (25 cm) on a side.
Enlarge each pattern 216%.

Campanula, Flower 1, piecing diagram

Sew: A1 to A2 to A3
B1 to B2
C1 to C2 to C3
D1 to D2 to D3 to C
E1 to E2 to E3 to E4 to CD
F1 to F2 to F3
F4 to F5 to F(1,2,3)
F to CDE to B to A

Campanula, Flower 1, asymmetrical triangular block pattern

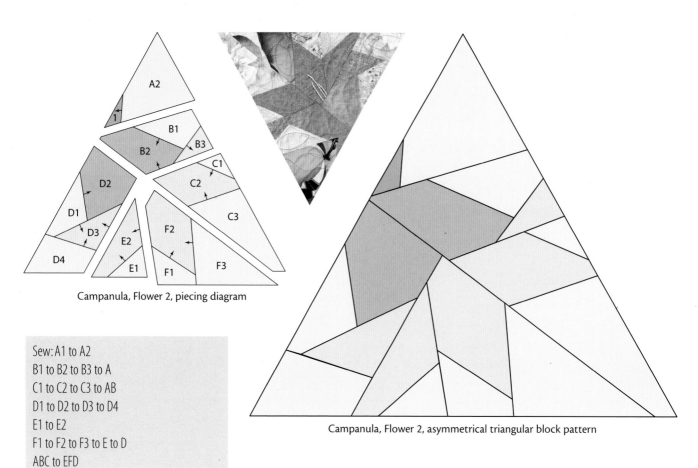

Campanula, Flower 2, piecing diagram

Sew: A1 to A2
B1 to B2 to B3 to A
C1 to C2 to C3 to AB
D1 to D2 to D3 to D4
E1 to E2
F1 to F2 to F3 to E to D
ABC to EFD

Campanula, Flower 2, asymmetrical triangular block pattern

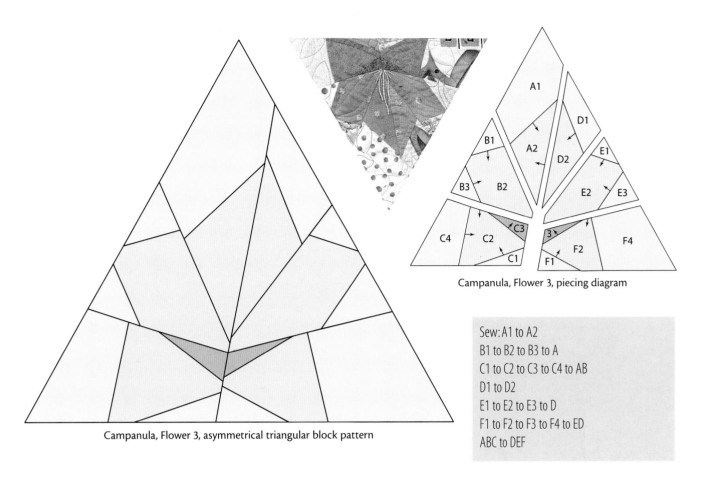

Campanula, Flower 3, piecing diagram

Campanula, Flower 3, asymmetrical triangular block pattern

Sew: A1 to A2
B1 to B2 to B3 to A
C1 to C2 to C3 to C4 to AB
D1 to D2
E1 to E2 to E3 to D
F1 to F2 to F3 to F4 to ED
ABC to DEF

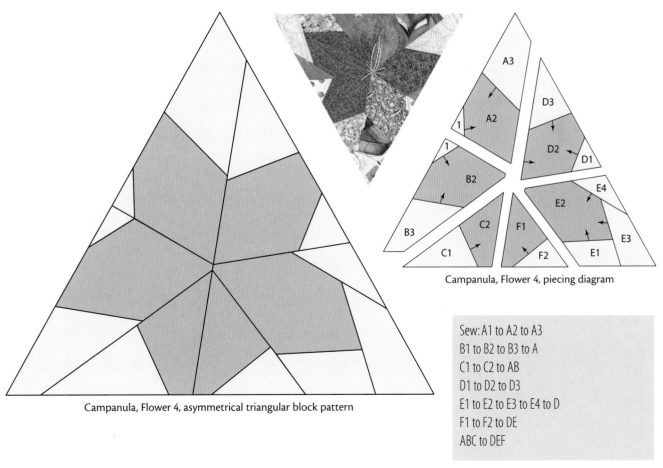

Campanula, Flower 4, piecing diagram

Campanula, Flower 4, asymmetrical triangular block pattern

Sew: A1 to A2 to A3
B1 to B2 to B3 to A
C1 to C2 to AB
D1 to D2 to D3
E1 to E2 to E3 to E4 to D
F1 to F2 to DE
ABC to DEF

Straight Seams

A symmetrical version of Campanula

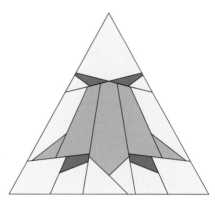

Campanula, straight seams,
symmetrical block

I chose to approach this design by looking at a side view, and developing a straight-seam piecing design in an equilateral triangle.

I set the flower up to be symmetrical in the fashion of most traditional quilt blocks. The exception to the mirror symmetry is the slanted line at the center point of the petals, which is drawn this way for ease of piecing.

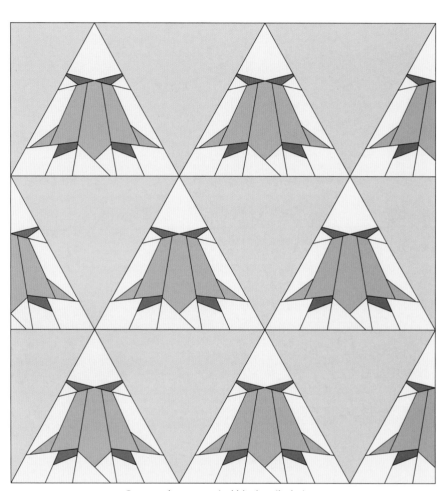

Campanula symmetrical block quilt design

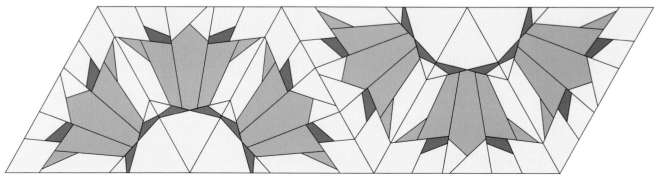

Campanula symmetrical block border and quilt design variation

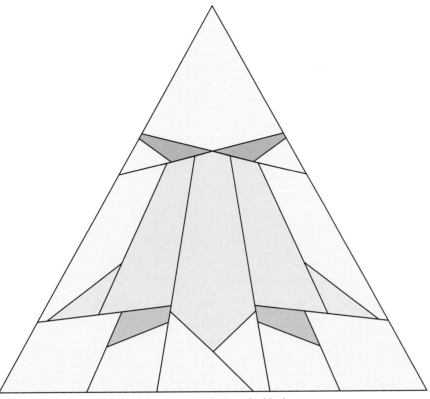

Campanula, symmetrical triangular block pattern

Make this triangle block 10 inches (25 cm) on a side for ease of piecing. Enlarge the pattern 216%.

One of the advantages of symmetrical blocks like this one is a minimum number of templates. In this case, A1 and A2 are the reverses of B1 and B2, as are the templates in C and CR and D and DR.

A disadvantage of symmetrical blocks is the number of seams that must match in many arrangements. Notice how the seams meet where the calyx joins the bell within the block and along the edges of the block's border on the opposite page.

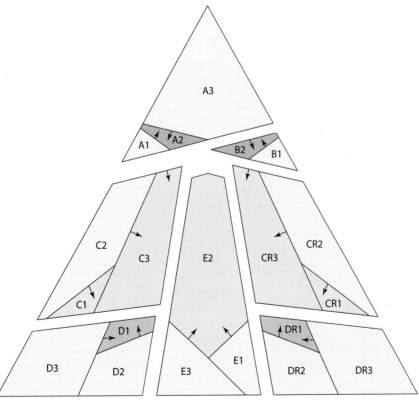

Campanula, straight seams, piecing diagram

Sew:
A1 to A2 to A3
B1 to B2
C1 to C2 to C3
D1 to D2 to D3 to C
E1 to E2 to E3 to CD
CR1 to CR2 to CR3
DR1 to DR2 to DR3 to CR to CDE
CDECRDR to B to A

Columbine

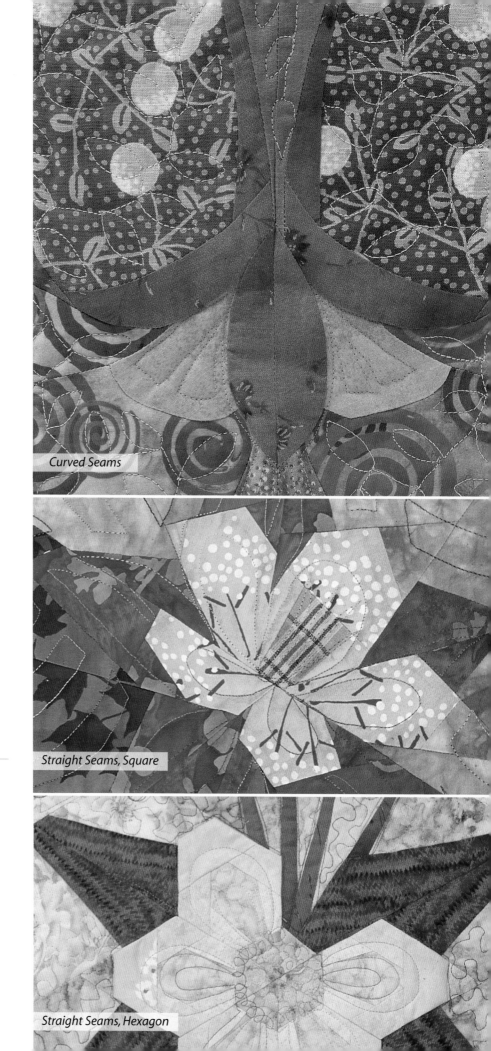

Curved Seams

Straight Seams, Square

Straight Seams, Hexagon

Columbine is a very three-dimensional flower. Its face exhibits five-part symmetry, with rings of rounded inner petals and an outer ring of more pointed ones, that extends backward into spurs. In some of the hybrid varieties, these spurs reach extraordinary lengths.

Curved Seams

A curved-seam version of Columbine

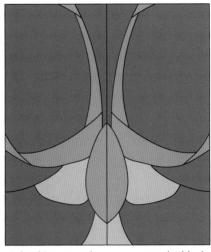

Columbine, curved seams, rectangular block

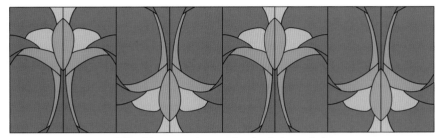

Columbine, curved seams, border design variation

For the first version of a columbine, I planned a rectangular flower block with curved seams. The flower is greatly simplified, showing two yellow petals, three red petals, and two spurs.

The style is reminiscent of Art Noveau, and makes a lovely border design as well as an all-over block pattern. The block is pieced in two halves, one the mirror image of the other, each half containing eleven templates.

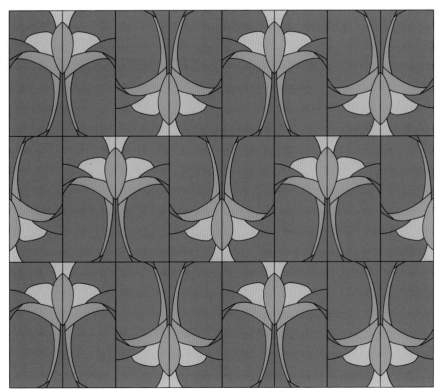

Columbine, curved seams, quilt design

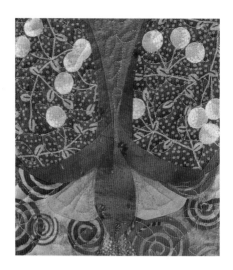

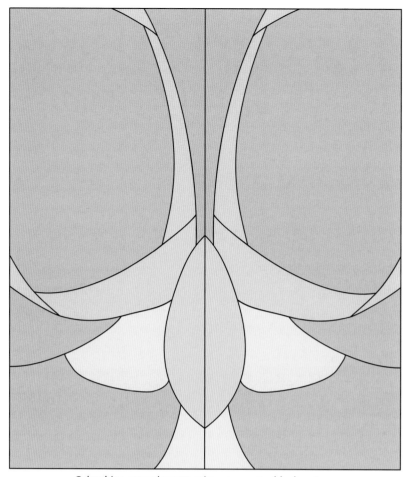

Although I have pieced this block at 7 inches by 8 inches (about 18 by 20 cm), I recommend that you make it larger. Enlarge the pattern 215% to about 9 by 11 ¾ inches.

Columbine, curved seams, mirror symmetry block pattern

Sew:
A1 to A2 to A3 to A4 to A5 to A6
AR1 to AR2 to AR3 to AR4 to AR5 to AR6
B1 to B2 to B3 to B4 to A
BR1 to BR2 to BR3 to BR4 to AR
AB to C
ARBR to CR
ABC to ARBRCR

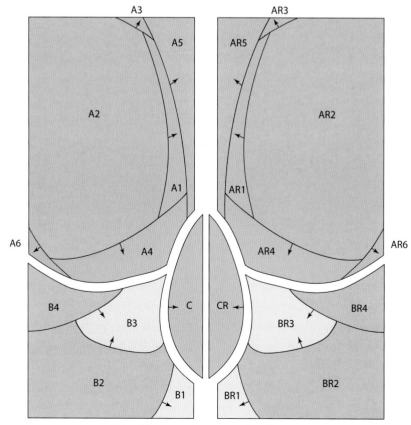

Columbine, curved seams, piecing diagram

Straight Seams

A square version of Columbine

Columbine, straight seams,
face view

Columbine, straight seams,
side view

Columbine, straight seams,
leaf and bud

For a more intricate version of columbine, I designed three square blocks. One is a face view of the flower, one a side view, and one a leaf and bud. These are all straight-seam piecing, but with a large number of templates.

The square blocks can be turned in place in different directions to make a number of different designs. An additional feature of these square blocks is that they each contain some of the same piecing lines. These common seams allow for many different ways of coloring the backgrounds of all of the blocks to connect them visually.

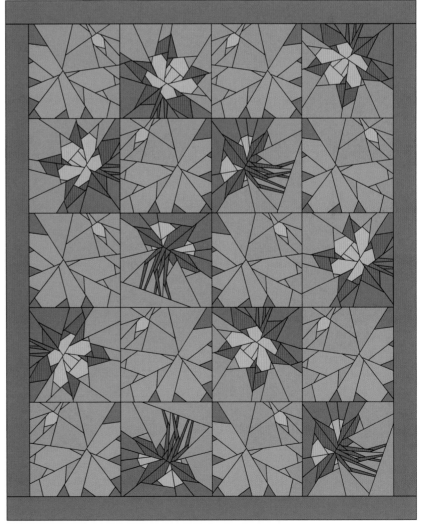

Columbine square block quilt design

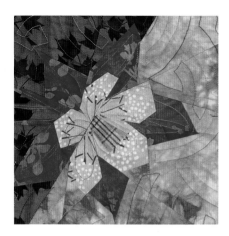

Make the block 8 by 8 inches (20 x 20 cm).
Enlarge the pattern 178%.

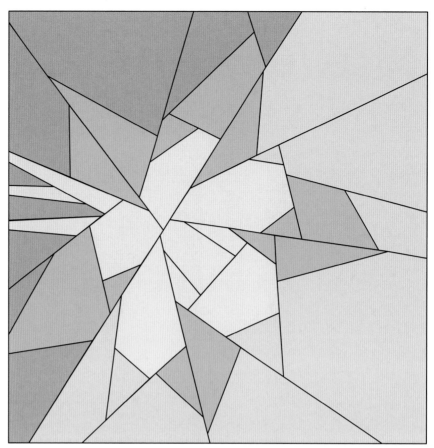

Columbine, face view, straight seams, square block pattern

Sew:
A1 to A2
B1 to B2 to B3, B4 to B5 to B6 to B(1,2,3) to A
C1 to C2 to C3 to C4 to C5 to C6, C7 to C8 to
 C(1,2,3,4,5,6) to AB
D1 to D2 to ABC
E1 to E2 to E3, E4 to E5 to E(1,2,3) to ABCD
F1 to F2 to F3 to F4 to F5
G1 to G2 to G3 to G4 to G5 to G6 to F
H1 to H2 to GF
I1 to I2 to I3 to I4 to I5, I6 to I7
 to I(1,2,3,4,5) to FGH
ABCDE to FGH I

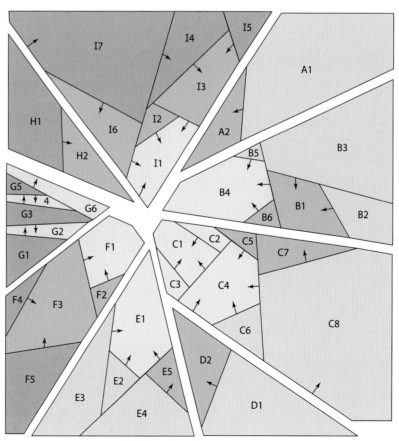

Columbine, face view, piecing diagram

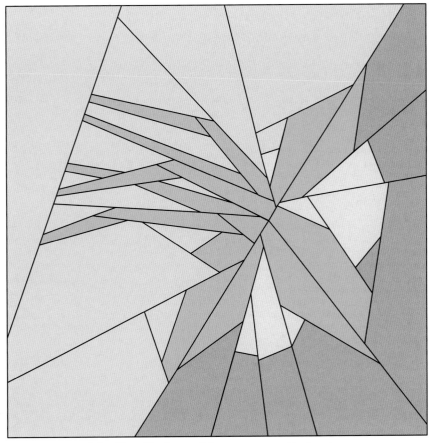

Columbine, side view, straight seams, square block pattern

Make the block 8 by 8 inches (20 x 20 cm).
Enlarge the pattern 178%.

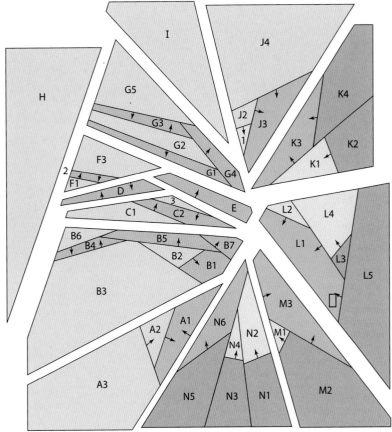

Columbine, side view, piecing diagram

Sew:
A1 to A2 to A3
B1 to B2 to B3 to B4 to B5 to B6 to B7
C1 to C2 to C3 to B to A to D to E
F1 to F2 to F3 to ABCDE
G1 to G2 to G3 to G4 to G5 to ABCDEF
ABCDEFG to I to H
J1 to J2 to J3 to J4 to ABCDEFGHI
K1 to K2, K3 to K4 to K(1,2)
L1 to L2, L3 to L4 to L(1,2) to L5
M1 to M2 to M3
N1 to N2, N3 to N4 to N(1,2)
N5 to N6 to N(1,2,3,4) to M to L to K
 to ABCDEFGHIJ

Make the block 8 by 8 inches (20 x 20 cm).
Enlarge the pattern 178%.

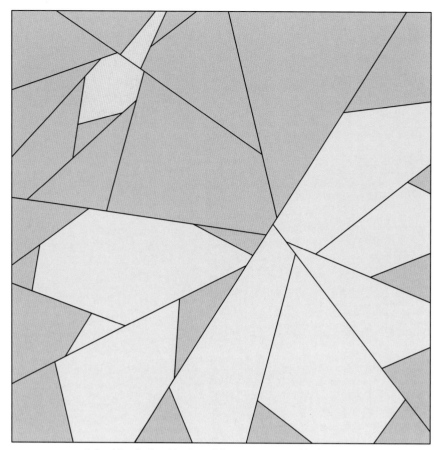

Columbine, leaf and bud, straight seams, square block pattern

Sew:
A1 to A2 to A3 to A4 to A5 to A6 to A7
B1 to B2 to B3 to B4 to A to C
D1 to D2 to D3 to D4 to D5 to D6 to D7
E1 to E2 to E3 to E4 to E5 to D
F1 to F2 to F3
G1 to G2 to G3 to G4, G5 to G6 to G(1,2,3,4)
 to F to ABC
FGABC to DE

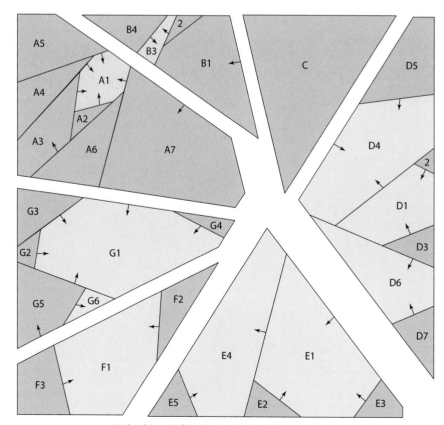

Columbine, leaf and bud, piecing diagram

Straight Seams

A hexagon version of Columbine

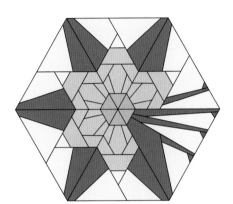

Columbine, straight seams,
flower hexagonal block

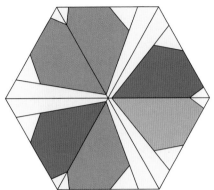

Columbine, straight seams,
leaf hexagonal block

I chose the hexagon shape because it will tessellate both by itself (Grandmother's Flower Garden style) and with equilateral triangles in symmetric and in irregular ways. The regular hexagon can also be turned in six different directions in any location to allow an element of randomness in the design. Using the six-sided hexagon breaks the five-part symmetry of the flower slightly, but shows a composite view of both the face and the spurs.

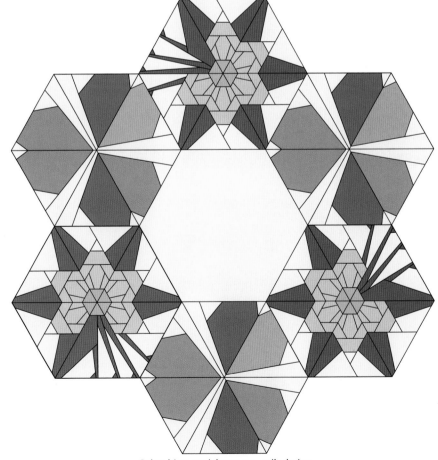

Columbine, straight seams, quilt design

The flower is made by dividing the hexagon into six triangles, four pieced identically and symmetrically to speed the chain-piecing process, one a slight adaption of that triangle, and one containing most of the spurs. Depending on the size of your block, you may want to make the spurs as sew-and-flip, or appliqué, or narrow inset folded edge.

I suggest enlarging the hexagon to about 6 inches (15 cm) on a side for ease of piecing. Enlarge the pattern 255%.

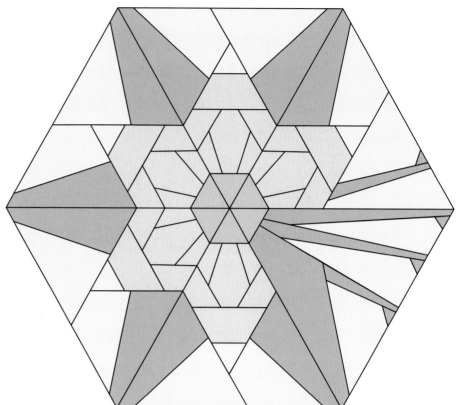

Columbine, flower, straight seams, hexagonal block pattern

Sew:
A1 to A2
B1 to B2 to BR2 to B3 to BR3 to B4 to B5 to B6
A to B
Make 5

Sew: C1 to C2
Make 4
Sew each to an AB

Sew: D1 to D2 to D3 to D4
Make 1
Sew to the remaining AB

Sew: E1 to E2 to E3 to E4
E5 to E6 to E7
E8 to E9 to E10
E(1,2,3,4) to E(5,6,7) to E(8,9,10)to E11
Make 1

Columbine, flower, piecing diagram

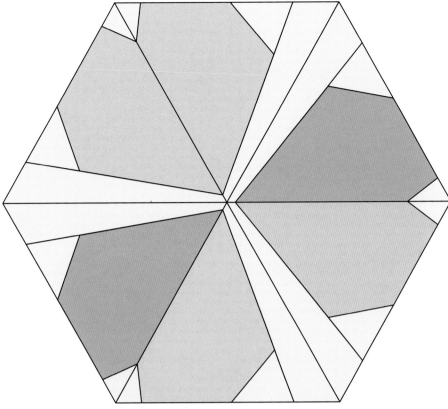
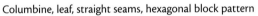

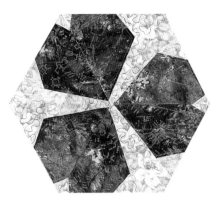

A second hexagon makes a leaf, composed of six triangles again, three identical and three mirrored images, also easily chain pieced.

Make the block so the hexagon is 6 inches on a side. Enlarge the pattern 255%.

Columbine, leaf, straight seams, hexagonal block pattern

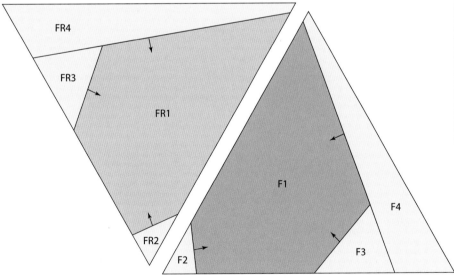

Columbine, leaf, piecing diagram

Sew:
F1 to F2 to F3 to F4
Make 3

Sew: FR1 to FR2 to FR3 to FR4
Make 3

Sew F(1,2,3,4) to FR(1,2,3,4)

Cosmos

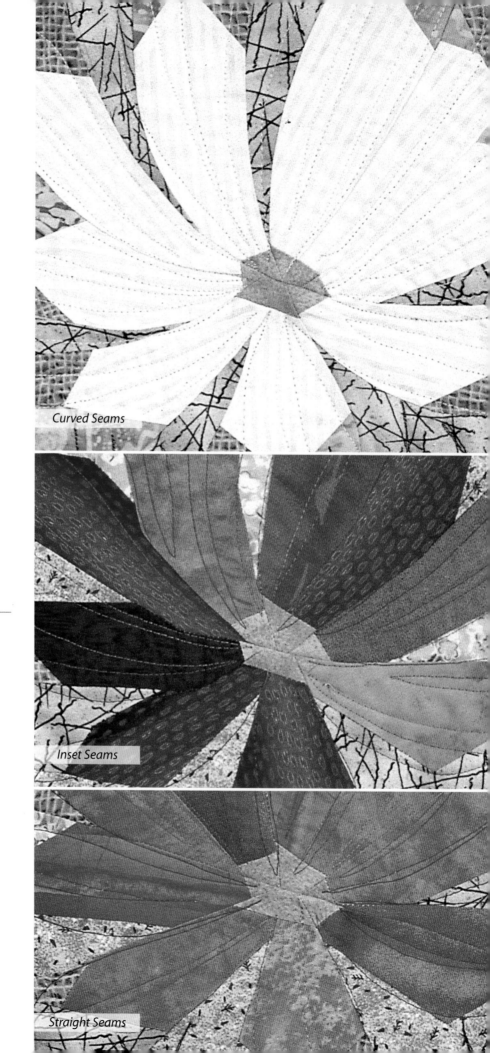

Curved Seams

Inset Seams

Straight Seams

Cosmos bloom late in the year atop feathery dill-like foliage. The slightly up-curved petals in shades of red, pink, and white are broader and somewhat fewer than those of a daisy. Other colors include red, orange, and yellow, with some picotee and fancy types. The three different styles of piecing present slightly different visual images and also present different technical problems in construction.

Curved Seams

A curved-seam version of Cosmos

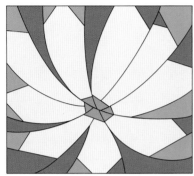

Cosmos, curved seams,
flower rectangular block

Cosmos, curved seams,
leaf rectangular block

Curved seams are somewhat slower to sew than straight seams. Had I curved the ends of the petals as well as the sides, the number of short curved seams would have made this block extremely tedious to sew. The pieced block would not have looked significantly different than this one with the short straight seams at the ends of the petals.

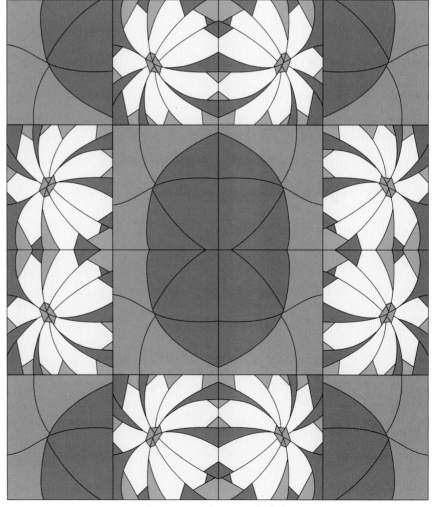

Cosmos curved seams quilt design

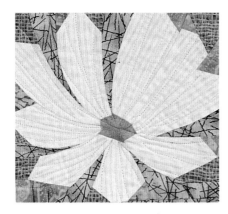

I have pieced the blocks 7 by 8 inches (about 18 by 20 cm) but they could be equally effective at a larger size. Enlarge the pattern 175%.

Sew: A1 to A2 to A3 to A4 to A5
B1 to B2 to B3, B4 to B5 to B6 to B(1,2,3) to B7
C1 to C2 to C3 to C4 to B to A
D1 to D2 to D3 to D4 to D5
E1 to E2 to E3 to E4, E5 to E6 to E7 to E(1,2,3,4) to E8 to D
F1 to F2 to F3 to F4 to F5 to F6 to F7 to ED
ABC to DEF

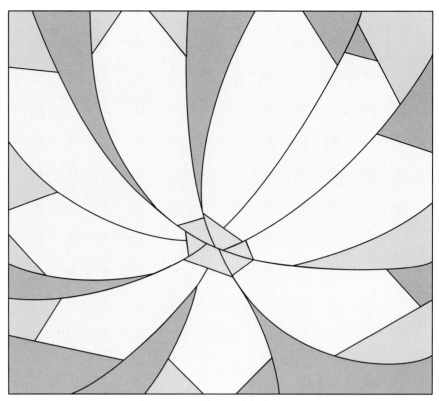

Cosmos, curved seams, block pattern

Piecing diagram, curved seam, background block. Trace from the enlarged flower block.

Sew:
A1 to A2 to A3
B1 to B2 to B3 to A

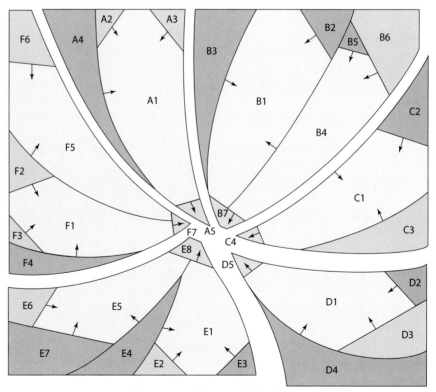

Cosmos, curved seams, piecing diagram

Inset Seams

An inset corner-seam version of Cosmos

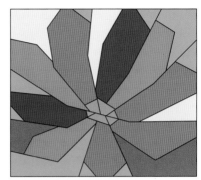

Cosmos, inset corner seams,
flower rectangular block

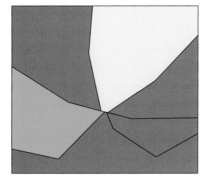

Cosmos, inset seams,
leaf rectangular block

Inset corner piecing* is not difficult with practice (especially for these wide angles) and uses fewer templates than straight seam piecing.

*Refer to Appendix, page 109.

Cosmos inset corners quilt design

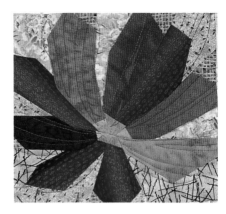

I pieced the blocks 7 by 8 inches (about 18 by 20 cm) but they could be equally effective at a larger size. Enlarge the pattern 175%.

Sew: A1 to A2 to A3, A4 to A5 to A(1,2,3)
B1 to B2 to B3, B4 to B5 to B(1,2,3) to B6 to A
C1 to C2 to C3 to C4 to AB
D1 to D2 to D3
E1 to E2 to E3, E4 to E5 to E6 to E(1,2,3) to
 E7 to D
F1 to F2 to F3 to F4 to DE
ABC to DEF

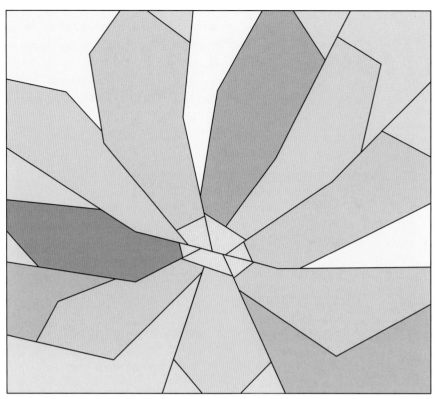

Cosmos, inset corner seams, block pattern

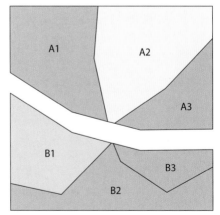

Piecing diagram, inset corner seam, background block. Trace from the enlarged flower block.

Sew:
A1 to A2 to A3
B1 to B2 to B3 to A

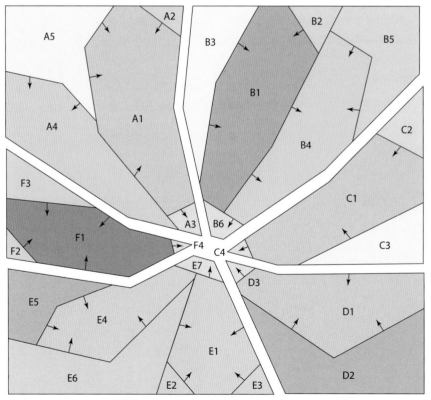

Cosmos, inset corner seams, piecing diagram

Straight Seams

A straight-seam version of Cosmos

Cosmos, straight seams,
flower rectangular block

Cosmos, straight seams,
leaf rectangular block

The straight seam version has more templates, but the sewing of pieces is slightly quicker to do.

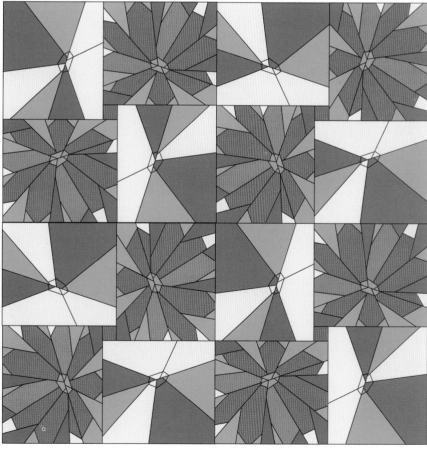

Cosmos straight seams quilt design

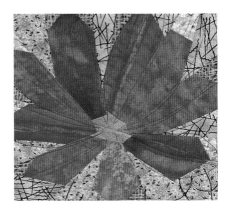

I have pieced the blocks 7 by 8 inches (about 18 by 20 cm) but they could be equally effective at a larger size. Enlarge the pattern 175%.

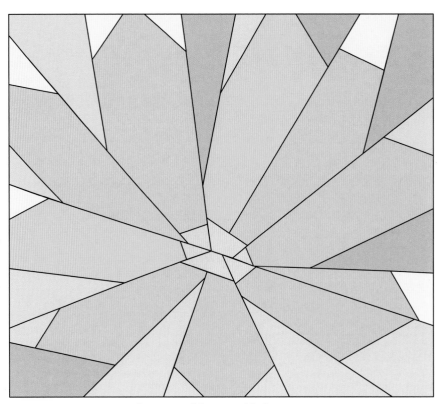

Cosmos, straight seams, block pattern

Sew: A1 to A2 to A3 to A4 to A5, A6 to A7 to A8 to A(1,2,3,4,5)

B1 to B2 to B3 to B4, B5 to B6 to B7 to B(1,2,3,4) to B8 to A

C1 to C2 to C3, C4 to C5 to C(1,2,3) to C6 to AB

D1 to D2 to D3 to D4

E1 to E2 to E3, E4 to E5 to E6 to E7 to E(1,2,3) to E8 to D

F1 to F2 to F3 to F4 to DE

ABC to DEF

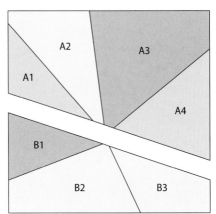

Piecing diagram, straight seam, background block. Trace this block from the enlarged flower block.

Sew:
A1 to A2 to A3 to A4
B1 to B2 to B3 to A

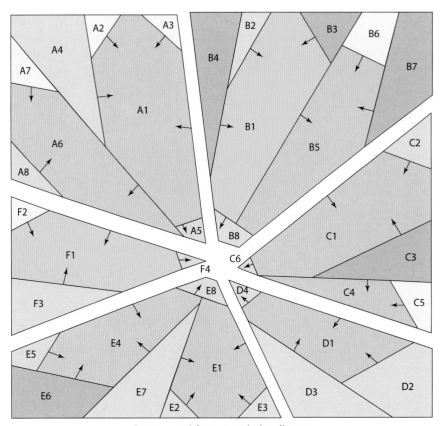

Cosmos, straight seams, piecing diagram

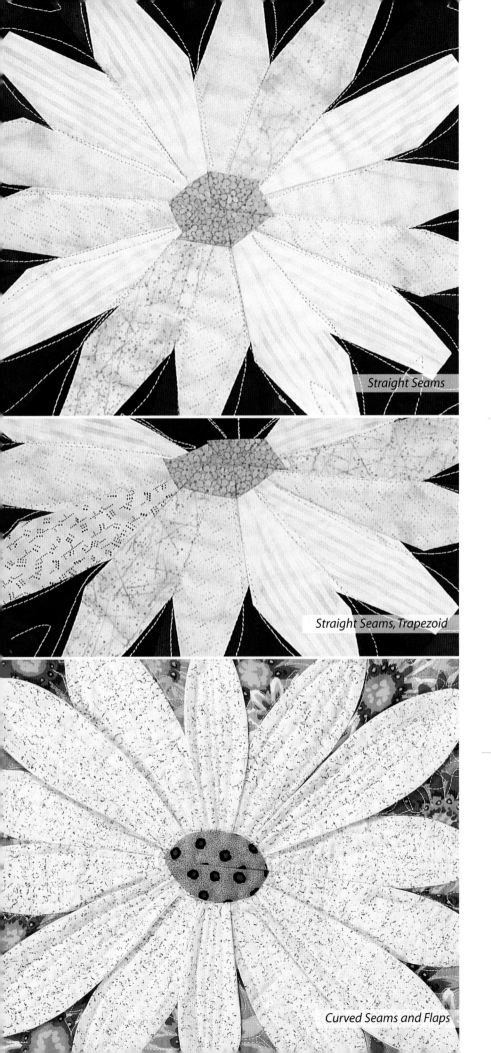

Straight Seams

Straight Seams, Trapezoid

Curved Seams and Flaps

Daisy

There are many flowers similar

in structure to the daisy.

Sew these blocks with different

colors to make asters or single

chrysanthemums, or use the

adapted center to make rudbeckias

or purple coneflowers.

Straight Seams

A straight-seam version of Daisy

Daisy blocks, side view and face view

I pieced the daisy block so the full flowers (two large trapezoids joined) are 7 ¾ inches by 10 inches (19.6 cm by 25 cm) and the side view flower (a large and small trapezoid joined) is 4 ¾ inches by 10 inches (12 cm by 25 cm). While this size is readily pieced, it does seem a little condensed. I would prefer you make the blocks 10 inches by 13 inches and 6 inches by 13 inches.

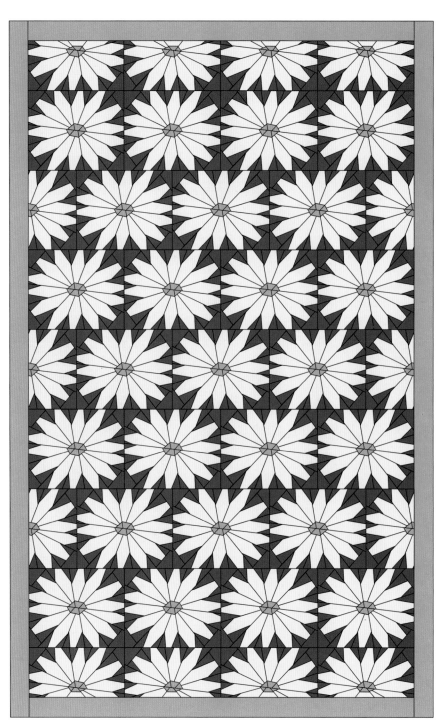

Daisy trapezoid block quilt design

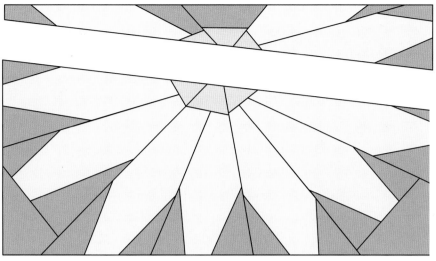

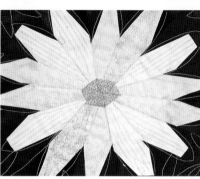

Patterns for daisy trapezoid blocks. Two blocks make a full-view flower.
One block plus a narrow trapezoid make a side-view flower

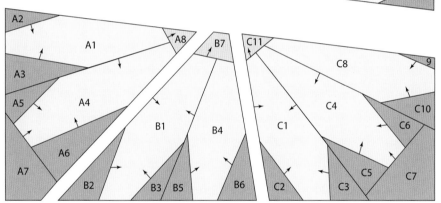

Side View Daisy, upper trapezoid
Sew: D1 to D2 to D3 to D4
D5 to D6 to D(1,2,3,4)
E1 to E2 to E3
E4 to E5 to E(1,2,3) to E6
For side view flowers, sew: D to E to ABC

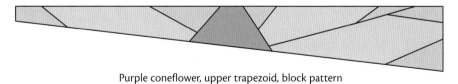

Piecing diagrams for daisy trapezoid blocks.
Fit wide and narrow trapezoids together to make face view and side view flowers.

Side View Daisy, lower trapezoid
Sew: A1 to A2 to A3, A4 to A5 to A6 to A7
 to A(1,2,3) to A8
B1 to B2 to B3, B4 to B5 to B6 to B(1,2,3) to B7
C1 to C2 to C3
C4 to C5 to C6 to C7 to C(1,2,3)
C8 to C9 to C10 to C(1,2,3,4,5,6,7) to C11
 to A to B
For full view flower, sew: ABC to ABC

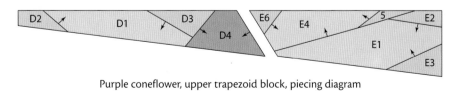

Purple coneflower, upper trapezoid, block pattern

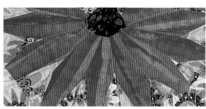

Purple coneflower, upper trapezoid block, piecing diagram

Side View Purple coneflower, upper trapezoid
Sew: D1 to D2 to D3 to D4
E1 to E2 to E3
E4 to E5 to E6 to E(1,2,3) to D
Prepare lower trapezoid same as daisy.

Enlarge the patterns 219%.

Curved Seams

A curved-seam version of Daisy

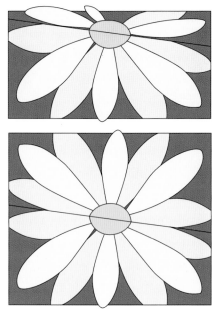

Daisy, face view and side view,
curved seams and faced flaps

One way to create flowers with many petals is to piece half of the petals and make the rest as faced flaps. The flaps can have interfacing or batting inserted in them during construction (or collar stays or covered wires) if desired, and be quilted before they are inserted into the piecing.

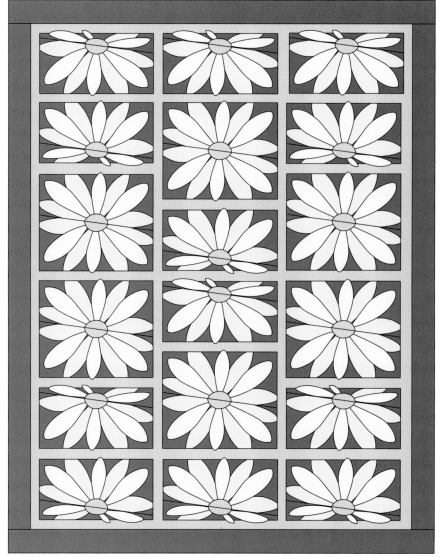

Daisy quilt design, curved seams and faced flaps

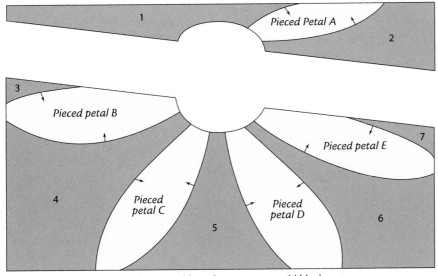

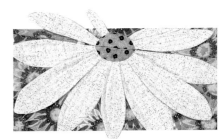

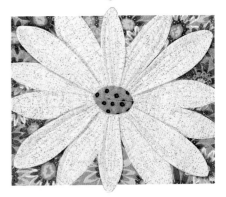

Daisy, curved seams, wide and narrow trapezoid block pattern

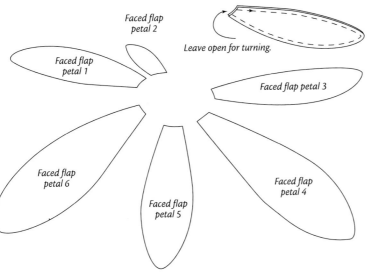

Daisy, curved seams, making the faced flaps

Enlarge the pattern and flaps 219%.

Sew:
1 to Petal A to 2
3 to Petal B to 4 to Petal C to 5 to Petal D to 6 to Petal E to 7
Prepare faced petals 1, 2, 3, 4 ,5 6.
Insert batting or interfacing if desired.
Trim faced petals 1, 2, 3, 4, 5, 6, turn, press, and quilt if desired.

If the narrow open end of the petal flaps is too small to turn them easily, you might slash what will be the underside of each petal to make it easier. When the petal flaps are quilted to the surface, the slashes will not show. In any case, you will probably want to do some quilting through the flaps in the finished quilt in order to keep them in place.

Baste or pin petals 1, 2, 3, 4, 5, 6 as indicated on partially pieced blocks.
Sew center 1 and center 2 catching raw edge of petals 1, 2, 3, 4, 5, 6.
Sew upper trapezoid to lower trapezoid.

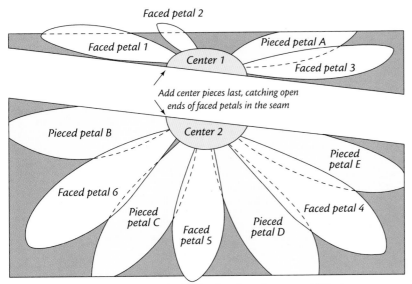

Daisy, curved seams, piecing the flaps into the trapezoid blocks

Day Lily

One of the staples of my summer garden, day lilies come in a wild variety of colors: yellows, oranges, reds, pinks, and purples, sometimes with dark eyes or chartreuse throats. With their strap-like leaves and interesting buds, they are truly intriguing for design.

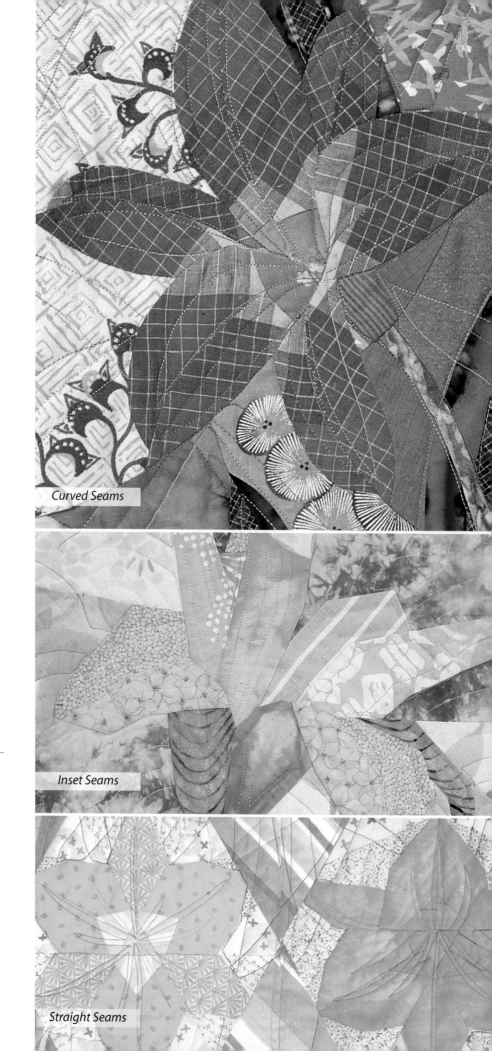

Curved Seams

Inset Seams

Straight Seams

Curved Seams

A curved-seam version of Day Lily

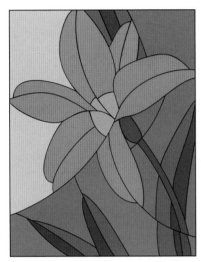

Day Lily, curved seams, rectangular block

For my first day lily, I have designed a single flower with pieced curved seams. After stacking up the rectangular blocks in columns, and making columns of reversed blocks, I've shifted the columns to produce this quilt design.

By working with two blocks at once, I planned a design in which two leaves at the lower edge of the block will connect with two leaves pieced at the top of the next block.

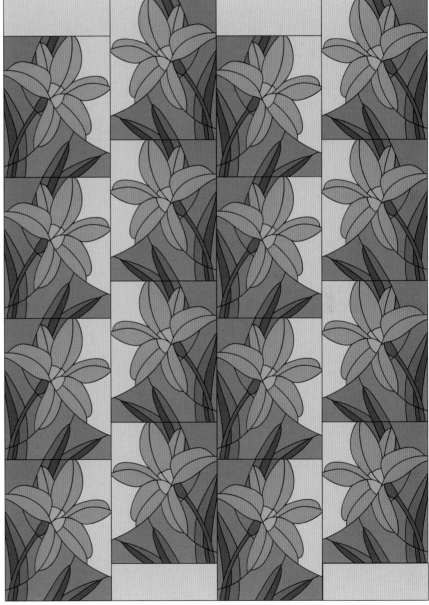

Day Lily, curved seam quilt design

Make the block at least 9 ½ by 12 inches (about 24 by 30 cm) for ease of sewing. Enlarge the pattern 245%.

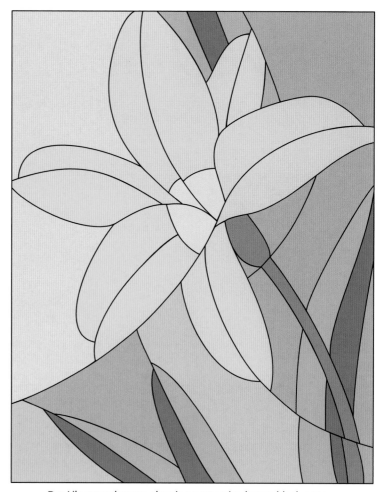

Day Lily, curved seams, showing connecting leaves, block pattern

Sew:
A1 to A2, A3 to A4 to A(1,2), A5 to A6 to A(1,2,3,4)
B1 to B2 partial seam as indicated, (for ease in completing next step), B (1,2) to B3
B(1,2,3) to A(1,2,3,4,5,6) between the two ●
Finish B2 seam.
C1 to C2 to C3 to C4 to C5 to C6 to C7 to C8 to C9 to C10 to AB
D1 to D2, E1 to E2 to E3 to D, F1 to F2 to F3 to F4 to F5 to F6 to F7 to DE
G1 to G2 to G3 to G4, G5 to G6 to G7 to G8 to G (1,2,3,4)
H1 to H2 to H3 to G to I to J to DEF
ABC to DEFGHI J

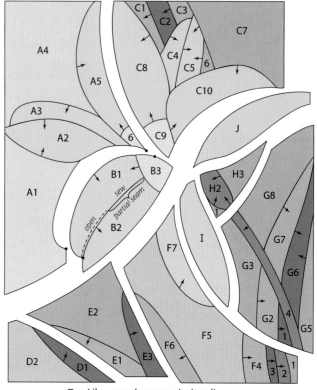

Day Lily, curved seams, piecing diagram

Inset Corner Seams

Symmetrical versions of Day Lily

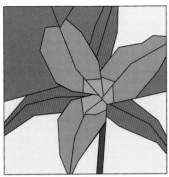

Day Lily, inset corner, front view 1

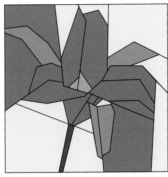

Day Lily, inset corner, front view 2

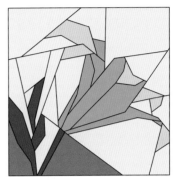

Day Lily, inset corner, side view 1

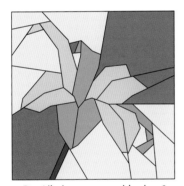

Day Lily, inset corner, side view 2

These four large square blocks, each with the day lily at a different angle, show straight-seam and inset-corner piecing.

These are planned for expert piecers. You should have mastered inset corners, Y seams and partial seaming techniques before starting to construct these. Refer to the Appendix, page 109, for more information.

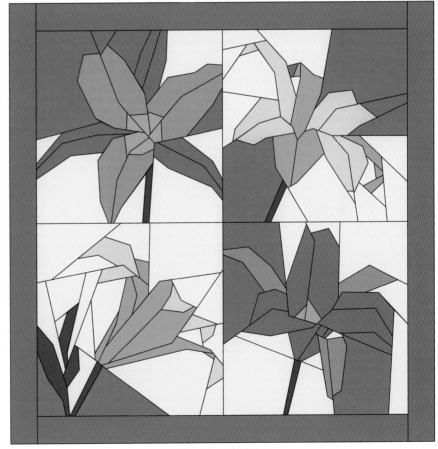

Day Lily quilt design

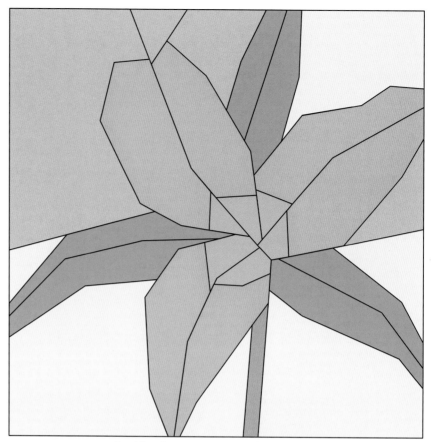

Day Lily 1, inset corner seams, block pattern

In making these blocks, I have enlarged the squares to 13 ½ inches (about 35 cm on a side). Enlarge the patterns 304%.

Rather than making plastic templates with included seam allowances, I would prefer you construct these blocks by tracing the enlarged blocks onto the shiny side of freezer paper with a fine-line permanent marker and using the freezer paper*, ironed to the wrong side of the fabric, to cut each piece. Cut the fabric, leaving a ¼ inch seam allowance around each freezer-paper piece. *Refer to the Appendix, page 111, for more information.

Sew:
A1 to A2 to A3 to A4 to A5
B1 to B2 to A
C1 to C2 to C3 to C4 to AB
D1 to D2 to ABC
E1 to E2 to E3 to E4
F1 to F2 to E
G1 to G2 to EF to I
H1 to H2 to H3 to EFGI
J1 to J2 to J3 to J4 to EFGHI, backstitch at
 ● Y seam
ABCD to EFGHI, backstitch at ● Y seam
J to C, backstitch at ● Y seam

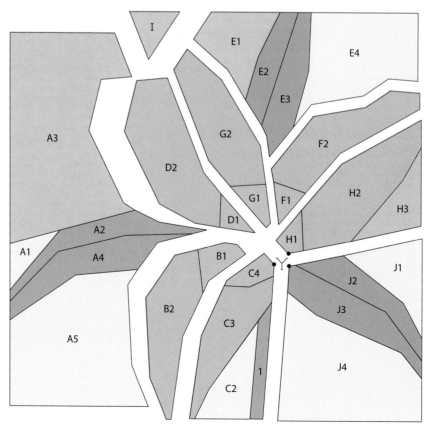

Day Lily 1, inset corner seams, piecing diagram

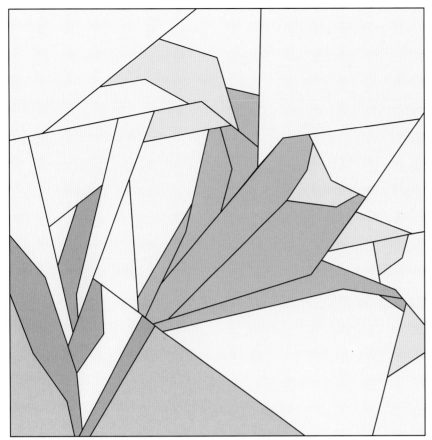

Day Lily 2, inset corner seams, block pattern

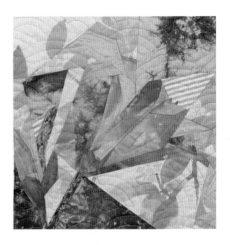

Enlarge the pattern 304%.

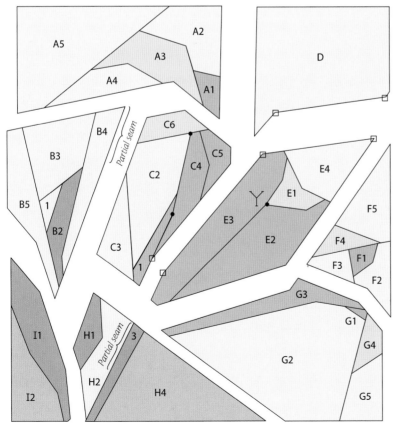

Day Lily 2, inset seams, piecing diagram

Sew:
A1 to A2 to A3 to A4 to A5
B1 to B2 to B3 to B4 to B5
C1 to C2 to C3 to C4 (only from ● to ●) to
 C5 to C6
Partial seam (⌣) B to C, Add A, Add D
E1 to E2 to E3, backstitching at ● Y seam, to E4
E to CD from □ to □ to □
Finish seam from ● (C1, C4) to end of E3
F1 to F2 to F3, F4 to F5 to F(1,2,3)
G1 to G2 to G3, G4 to G5 to G(1,2,3) to F to ED
H1 to H2, H3 to H4, H(1,2) to H(3,4)
 with partial seam (⌣)
H to CEG
Finish partial seam between B and CH
I1 to I2 to ABCDEFGH
Finish partial seam between H(1,2) and H(3,4)

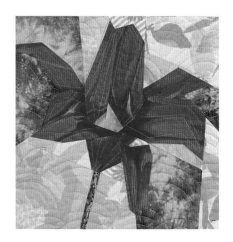

Enlarge the patterns 304%.

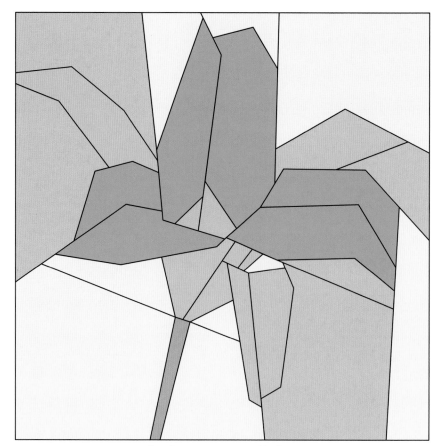

Day Lily 3, inset corner seams, block pattern

Sew:
A1 to A2 to A3 to A4
B1 to B2 to B3, B4 to B5 to B6 to B(1,2,3)
C1 to C2 to C3 to B
Join A to E from ● to ●, sew AE to BC
F1 to F2, H1 to H2
G1 to G2 to G3
I1 to I2 to I3
Join F to H with a partial seam (⌣)
Add G
Add J
HJ to I, backstitching at ● Y seam
I to K (backstitching at ● Y seam)
IK to L, finish Y seam by joining KL to GJ
Complete partial seam between F and HI
D1 to D2 to D3 to FGHIJKL to M
Join ABCE to DFGHIJKLM from □ to □
Finish last seam ○ to ● between A and EFG

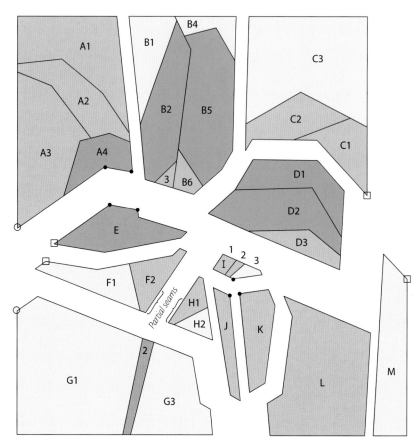

Day Lily 3, inset corner seams, piecing diagram

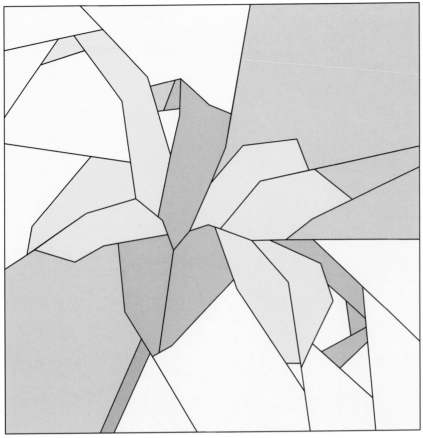

Day Lily 4, inset corner seams, block pattern

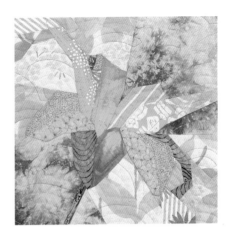

For the inset corner seams*, you will have to trace around the edge of the freezer paper to draw the seam line on the back of each fabric piece. You must then clip the fabric to the inset corner, then remove the freezer- paper pattern before sewing in order to be able to manipulate the fabric.

*Refer to the Appendix, page 109.

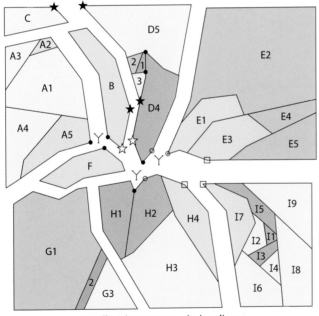

Day Lily 4, inset seams, piecing diagram

* seam allowance between D(1, 2, 3) and D4 meets the corner of the inset seam with D5. If you try to sew the entire inset seam between D(1, 2, 3, 4) and D5 at one pass, you will probably find this seam allowance gets caught and the seam will not lie as flat as when you do this seam in two sections, backstitching at the ●.

Sew:
A1 to A2 to A3, A4 to A5 to A(1,2,3) to B, backstitching at ● Y seam, to C
D1 to D2 to D3, D(1,2,3) to D4 from ● to ●
D5 to D(1,2,3,4) from edge to ●, backstitching at ● (see note on lower left)*
D4 to D5, backstitching at the ●
E1 to E2, E3 to E4 to E5 to E(1,2) to D, backstitching at ○ (Y seam)
G1 to G2 to G3
H1 to H2 insert backstitching a ● to H3 to H4 to G to F
A to FG from edge to ●
Join BC to D from ★ to ★
Finish partial seam between D3 and D4, and B, continuing to ☆
BD to (FH1), backstitch at both ends (Y seams)
I1 to I2 to I3 to I4 to I5 to I6 to I7 to I8 to I9
I to H, backstitching at □
D4 to H2 from ● to ○, backstitching at ○ (same problem as * above)
E(1,3) to H(2,4) from ○ to □, backstitching at □
E to I, backstitching at □

Straight Seams

Hexagon versions of Day Lily

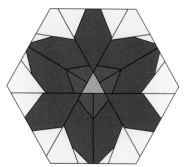

Day Lily, straight seam,
symmetrical, hexagonal block,
face view

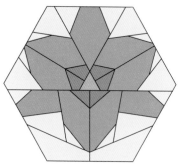

Day Lily, straight seam,
symmetrical, hexagonal block,
side view

This set of day lilies within hexagonal blocks is designed with only a few templates per block and all straight seams. I arranged the piecing so that no seams run into the corners of the blocks, which will make the blocks easier to join together in the quilt.

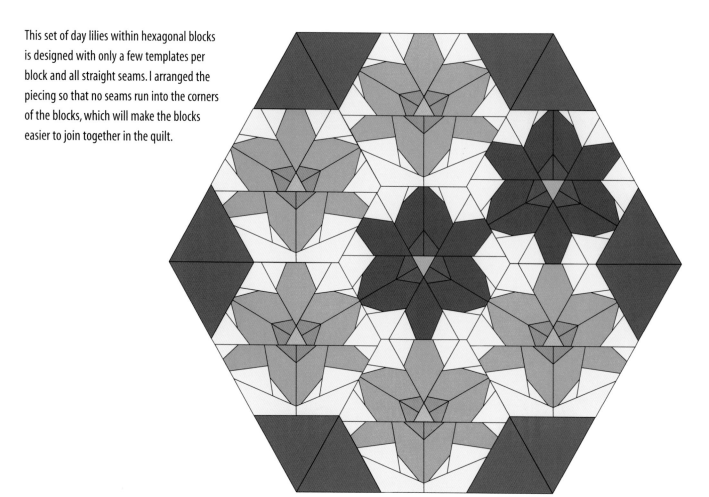

Hexagon block quilt design

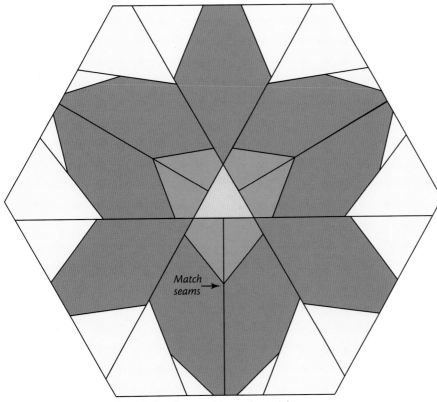

Day Lily face flower, wide petals, straight seams,
hexagonal block pattern

Match
seams →

Enlarge the pattern 216% to 5 inches
on a side.

Each hexagon is composed of three elements:
a small center triangle, a three-part block
making the narrower petal, and a broader
petal which is made in two mirror halves.
Because of the mirror halves, the seam on
the broader petal of each block where the
petal meets the eye should be matched
when piecing.

Sew:
A1 to A2 to A3 to A4, three times
AR1 to AR2 to AR3 to AR4 to A, three times
B1 to B2 to BR1, three times
One AAR to one B
One AAR to C to AARB
One B to the last AAR to the last B
Top to Bottom

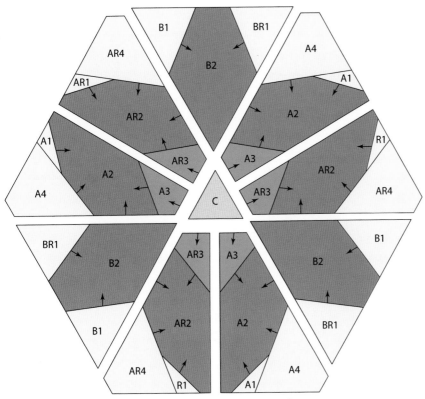

Day Lily face flower, wide petals, piecing diagram

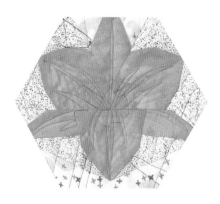

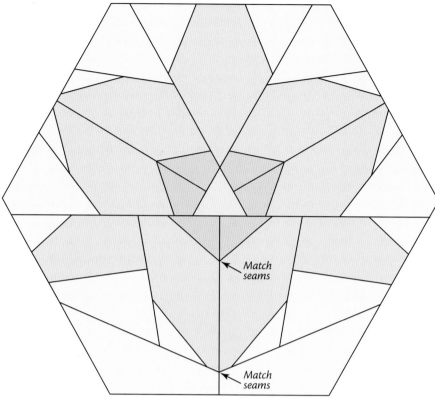

Enlarge the pattern 216% to 5 inches on a side.

Match seams

Match seams

Day Lily side flower, wide petals, straight seams, hexagonal block pattern

Sew:
A1 to A2 to A3 to A4, AR1 to AR2 to AR3 to AR4, twice
B1 to B2 to BR1
AAR to B, the other AAR to C
AARB to AARC
D1 to D2 to D3
E1 to E2 to E3 to D to F
ER1 to ER2 to ER3
DR1 to DR2 to DR3 to ER to FR
DEF to DRERFR
Top to Bottom

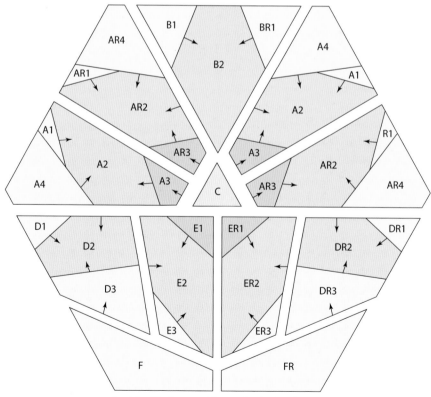

Day Lily side flower, wide petals, piecing diagram

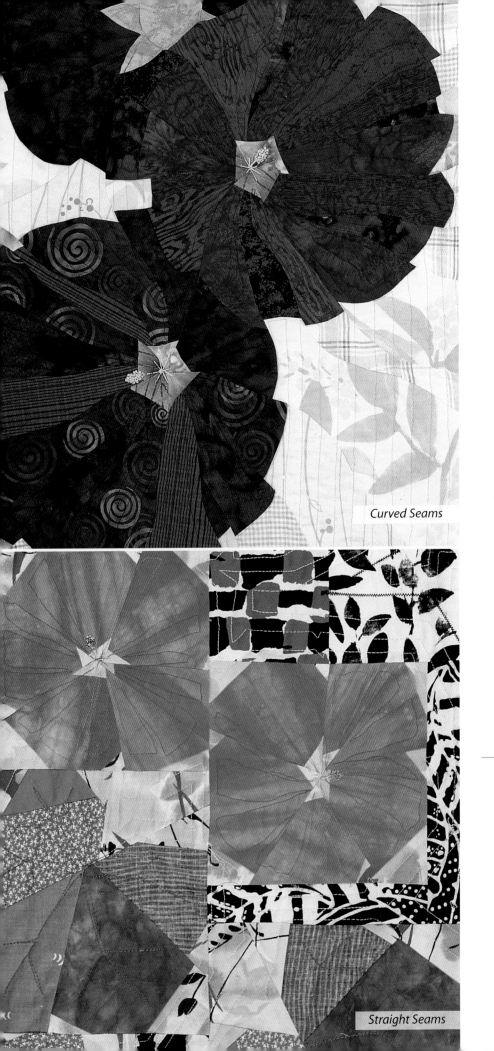

Curved Seams

Straight Seams

Hollyhock

To me, the hollyhock's pattern of growth

is the signature of the plant as much as

the blossom. The very tall straight stem,

rising from the base of leaves and bearing

open blooms and tight buds makes a

lovely sight against the gray clapboard

walls outside my kitchen.

Curved Seams

A curved-seam version of Hollyhock

I focused on two (and a half) flowers. I chose for
this quilt a variety of hollyhock with dark purple,
almost black, flowers called "The Watchman."
The design is composed of gentle curves.

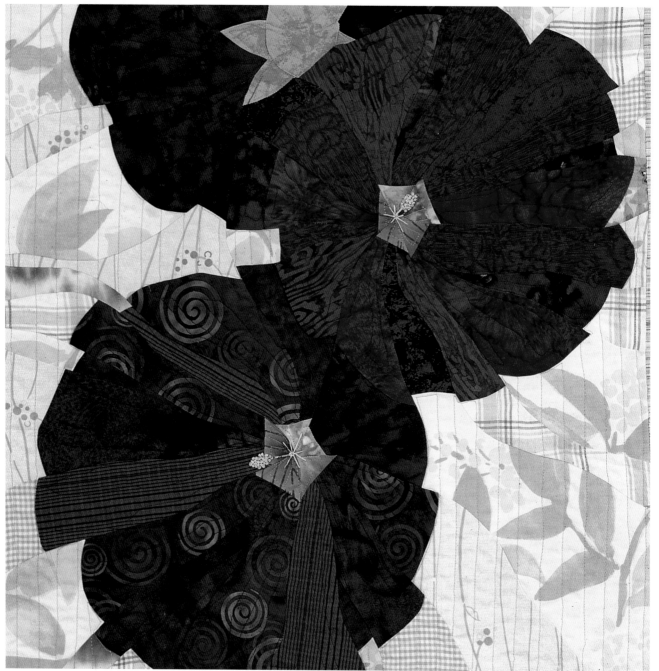

Hollyhock curved seam quilt

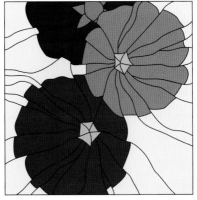

Hollyhock, curved seams

I've sewn the quilt as a small wallhanging 19 by 19 inches square (about 48 by 48 cm) without borders. The same design could certainly be made even bigger, or a number of blocks joined for a bed quilt. Free-motion quilting and hand embroidery complete the piece. Enlarge the pattern 272%.

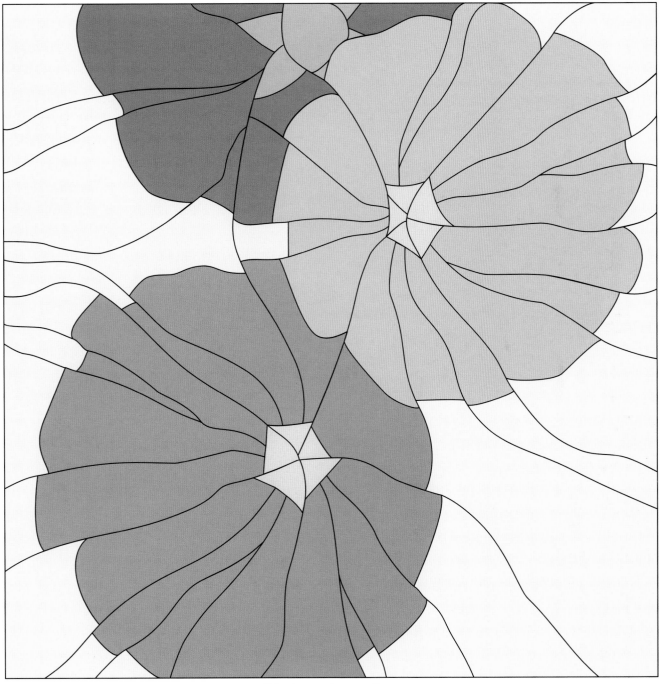

Hollyhock, curved seam quilt pattern

Sew:

A1 to A2, A3 to A4 to A(1,2), A5 to A6 to
 A(1,2,3,4) to A7 to A8

B1 to B2, B3 to B4 to B(1,2), B5 to B6, B7 to
 B8 to B(5,6) to B(1,2,3,4) to B9

A to B

C1 to C2, C3 to C4 to C5 to C(1,2)

D1 to D2, D3 to D4 to D(1,2), D5 to D6 to
 D(1,2,3,4), D7 to D8 to D(1,2,3,4,5,6)

C to D

E1 to E2 to E3, E4 to E5 to E(1,2,3), E6 to E7
 to E(1,2,3,4,5), E8 to E9 to E(1,2,3,4,5,6,7)
 to E10

E to CD to F

G1 to G2, G3 to G4 to G(1,2), G5 to G6 to
 G(1,2,3,4) to G7 to G8

H1 to H2 to H3, H4 to H5 to H(1,2,3), H6 to
 H7 to H(1,2,3,4,5) to H8

I1 to I5, I2 to I4 to I3 to I(1,5) to I6 to I7
 to I8 to I9 to I10

CDEF to I to H to G to AB

J1 to J2, J3 to J4 to J(1,2), J5 to J6 to
 J(1,2,3,4) to J7

K1 to K2, K3 to K4 to K(1,2), K5 to K6 to
 K(1,2,3,4), K7 to K8 to K(1,2,3,4,5,6) to K9

J to K to ABCDEFGHI

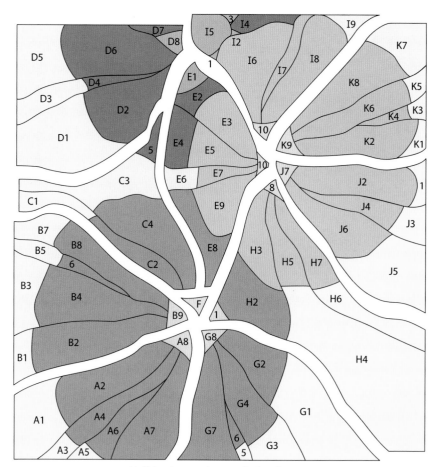

Hollyhock curved seam piecing diagram

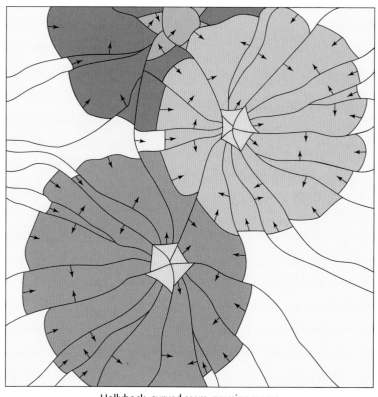

Hollyhock, curved seam, pressing seams,
(arrows indicate the direction in which to press the seam allowances)

Straight Seams

A straight-seam version of Hollyhock

I planned some relatively simple straight seam blocks, squares and a rectangle, but set them in an interesting way.

Rather than setting the blocks together edge to edge or with sashing, as with a standard quilt, I have put them together with a series of rectangles to make an entire hollyhock plant. For this design I have pieced four Leaf blocks, three Face Flower blocks, two Side Flower blocks and one Bud block.

Hollyhock, side flower,
straight seam block

Hollyhock, face flower,
straight seam block

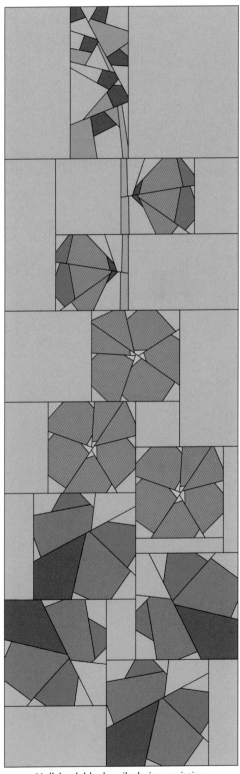

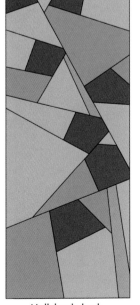

Hollyhock, buds,
straight seam block

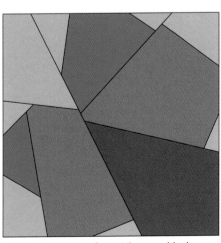

Hollyhock, leaf, straight seam block

Hollyhock block quilt design, variation

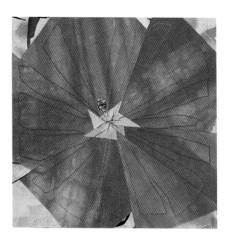

I've pieced this block 6 inches (about 15 cm) square. Enlarge the pattern 132%.

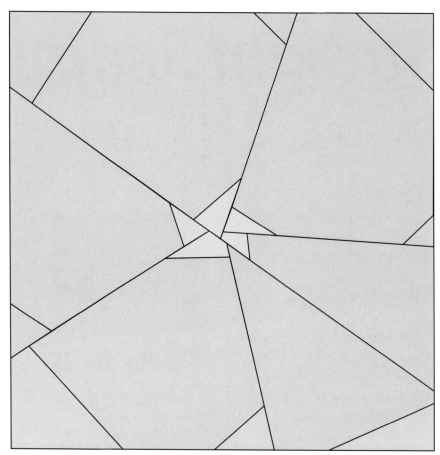

Hollyhock face flower, straight seams, block pattern

Sew:
A1 to A2 to A3 to A4
A5 to A6 to A(1,2,3,4)
B1 to B2 to B3 to B4 to B5 to B6
C1 to C2 to C3
D1 to D2 to D3 to D4
A to D
B to C
AD to BC

You may want to add the five small center triangles as sew-and-flip elements, rather than separate templates. In that case, cut the five petal pieces (A1, A5, B1, C1, D1) so that they extend to the center.

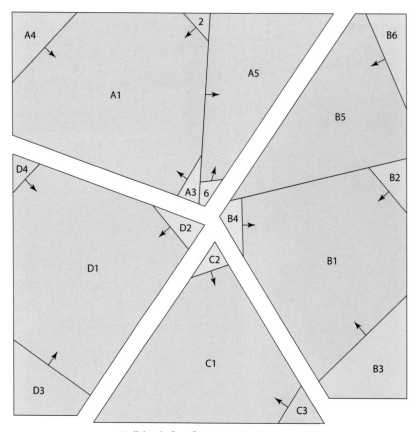

Hollyhock, face flower, piecing diagram

The side flower is in a 5 inch (about 12.7 cm) square. Enlarge the pattern 110%.

The hollyhock flowers surround the stem, so a side-view version is appropriate, too.

Hollyhock side flower, straight seams, block pattern

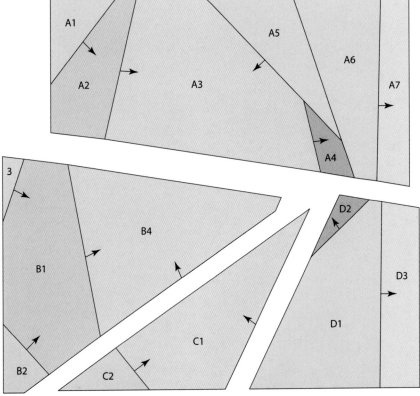

Sew:
A1 to A2 to A3 to A4 to A5 to A6 to A7
B1 to B2 to B3 to B4
C1 to C2
D1 to D2 to D3
B to C to D to A

Hollyhock side flower, piecing diagram

A leaf has also been placed in a square block, this time 7 inches by 7 inches (about 17.75 cm). Enlarge the pattern 153%.

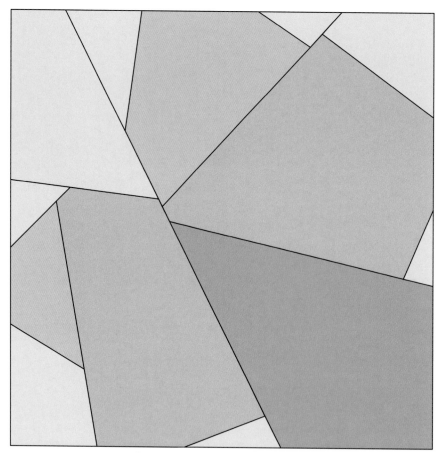

Hollyhock leaf, straight seams, block pattern

Sew:
A1 to A2 to A3 to A4 to A5 to A6
B1 to B2 to B3
C1 to C2 to C3 to C4
B to C to A

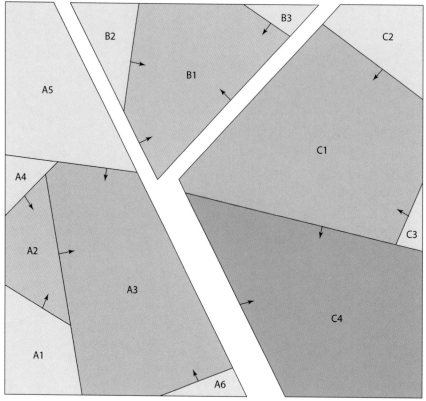

Hollyhock leaf piecing diagram

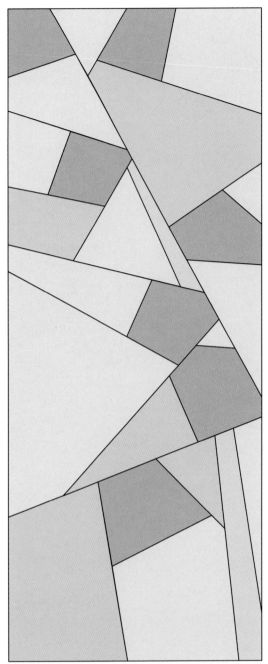

Hollyhock buds, straight seams,
rectangle block pattern

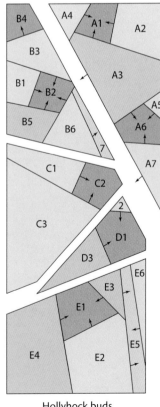

Hollyhock buds
piecing diagram

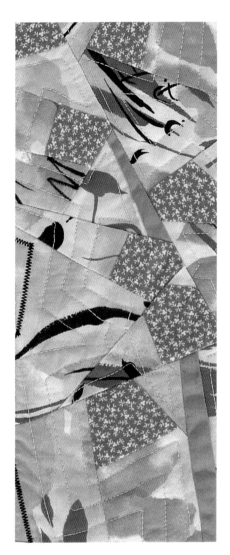

A cluster of buds in a rectangle 4 inches by
10 inches (about 10 by 25 cm) completes
the block set. Enlarge the pattern 148%.

Sew:
A1 to A2 to A3 to A4
A5 to A6 to A7 to A(1,2,3,4)
B1 to B2 to B3 to B4 to B5
B6 to B7 to B(1,2,3,4,5)
C1 to C2 to C3
D1 to D2 to D3
E1 to E2 to E3 to E4 to E5 to E6
B to C to D to E to A

Iris

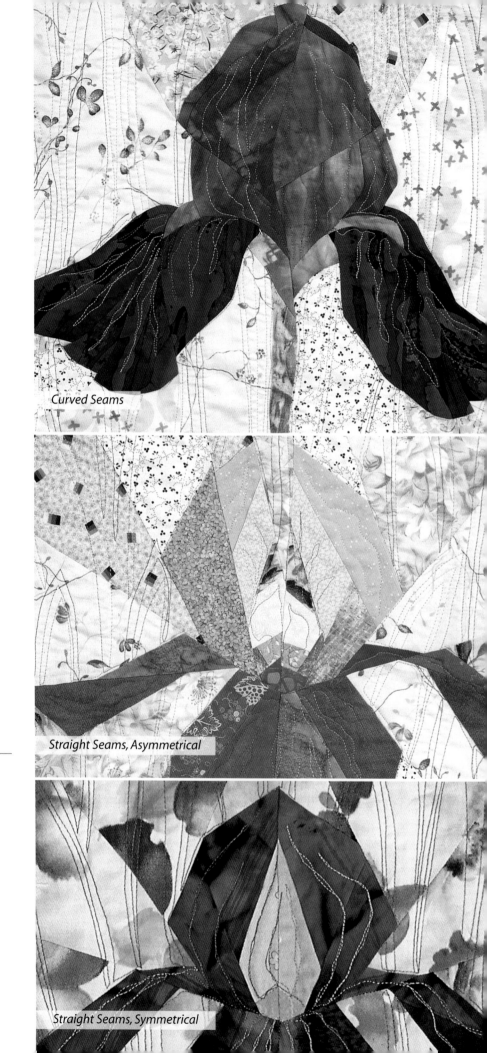

Curved Seams

Straight Seams, Asymmetrical

Straight Seams, Symmetrical

Tall bearded irises are dramatic flowers. They have been hybridized into an astonishing array of colors. This is a flower that grows in thirds, with three petals that stand up (standards) alternating with three petals that hang down (falls).

Curved Seams

Curved-seam versions of Iris

Iris, centered on a standard, curved seams, rectangular block

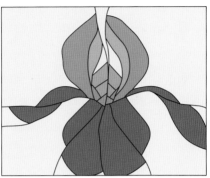

Iris, centered on a fall, curved seams, rectangular block

Streaky hand-dyed fabrics or batiks are natural choices for this flower, although the number of pieces allows for interesting shading with other fabrics as well.

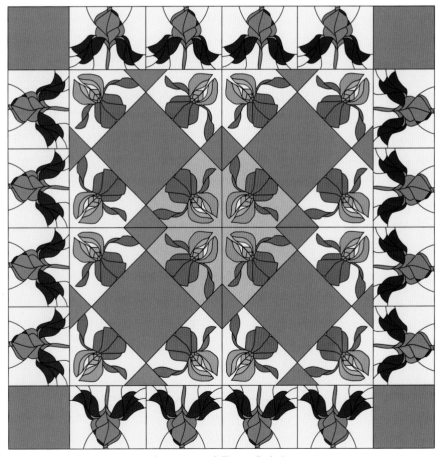

Iris, center medallion quilt design

I've pieced both of these blocks at about 11½ by 14 inches (about 29 by 36 cm). Enlarge these patterns 307%.

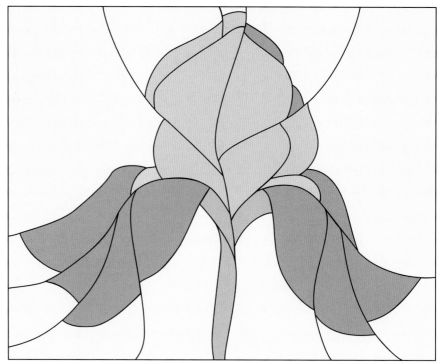

Iris, centered on a standard, curved seams, rectangular block pattern

Sew:
A1 to A2, A3 to A4 to A(1,2) to A5
B1 to B2 to B3 to B4 to B5 to A
C1 to C2, C3 to C4 to C(1,2)
D1 to D2 to D3 to D4 to C to AB
E1 to E2 to E3 to E4
F1 to F2 to F3 to F4 to F5 to E
G1 to G2 to G3
H1 to H2, H3 to H4 to H(1,2) to G to EF
ABCD to EFGH

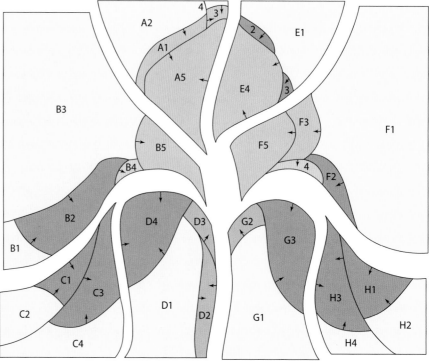

Iris, centered on a standard, curved seams, piecing diagram

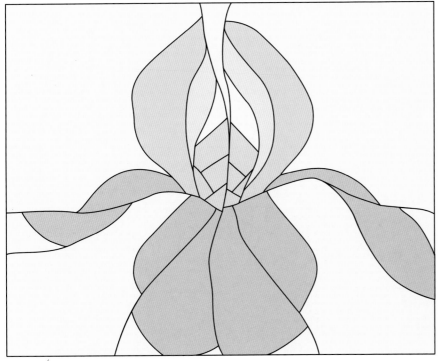

Iris, centered on a fall, curved seams, block pattern

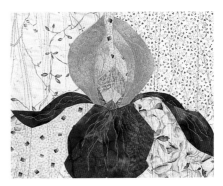

Because the blocks are large, you may want to make just a few. The freezer-paper template method* may be the best way to make them.
*Refer to the Appendix, page 111.

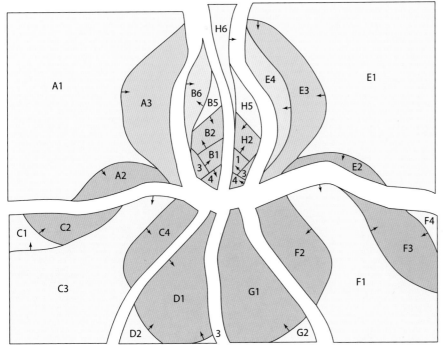

Iris, centered on a fall, curved seams, piecing diagram

Sew:
A1 to A2 to A3
B1 to B2 to B3 to B4 to B5 to B6 to A
C1 to C2 to C3 to C4
D1 to D2 to D3 to C to AB
H1 to H2 to H3 to H4 to H5
E1 to E2 to E3 to E4 to H(1,2,3,4,5) to H6
F1 to F2 to F3 to F4
G1 to G2 to F to EH
ABCD to EFGH

Straight Seams

Asymmetrical versions of Iris

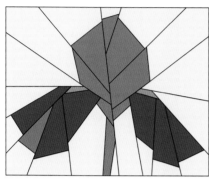

Iris, centered on a standard, straight seams, rectangular block

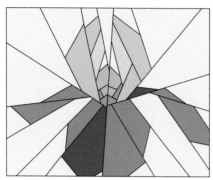

Iris, centered on a fall, straight seams, rectangular block

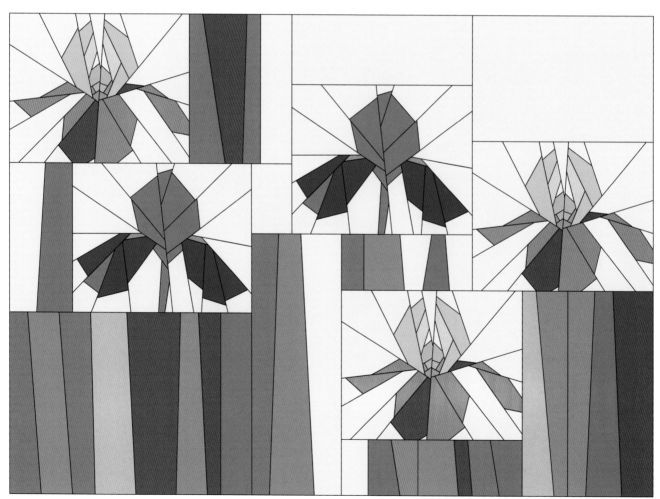

Five of the larger complex straight seam blocks set irregularly with rectangles of various sizes, some cut from a section of slightly angled strip-piecing

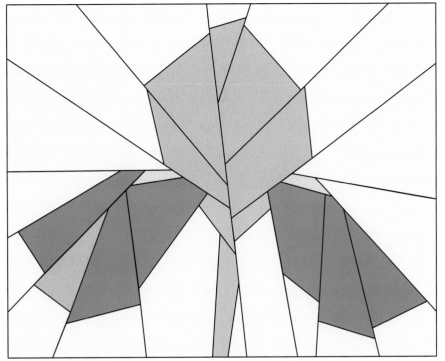

Iris, centered on a standard, straight seams, block pattern

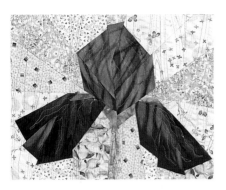

I chose a single large-scale print with purples and yellows for the background pieces, to suggest more flowers out-of-focus in the distance. Make the block 11½ by 14 inches (about 29 by 36 cm). Enlarge these patterns to 307%.

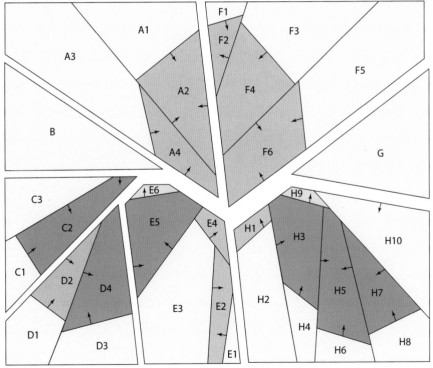

Iris, centered on a standard, straight seams, piecing diagram

Sew:
A1 to A2, A3 to A4 to A(1,2)
C1 to C2 to C3
D1 to D2, D3 to D4 to D(1,2)
E1 to E2 to E3 to E4 to E5 to E6 to D to C to
 B to A
F1 to F2, F3 to F4, F5 to F6 to F(3,4) to F(1,2)
H1 to H2, H3 to H4, H5 to H6, H7 to H8
H(1,2) to H(3,4) to H(5,6) to H(7,8) to H9
 to H10 to G to F
ABCDE to FGH

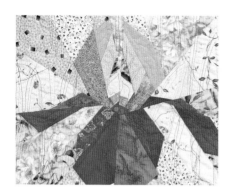

I've sewn both of these blocks at 11½ by 14 inches (about 29 by 36 cm). Enlarge these patterns to 307%.

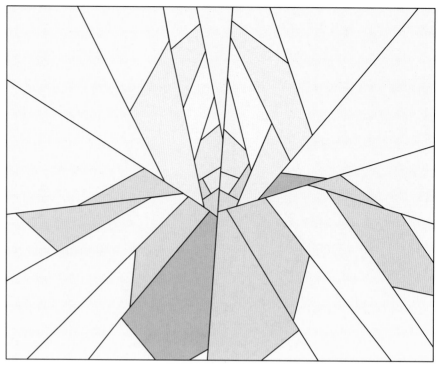

Iris, centered on a fall, straight seams, block pattern

Sew:
A1 to A2 to A3
B1 to B2 to B3 to B4 to B5 to B6 to B7 to B8 to B9 to A
C1 to C2, C3 to C4 to C5 to C(1,2)
D1 to D2 to D3, D4 to D5 to D(1,2,3) to C to AB
E1 to E2 to E3 to E4 to E5 to E6 to E7 to E8 to E9 to E10
F1 to F2 to E
G1 to G2
H1 to H2 to H3 to H4, H5 to H6 to H(1,2,3,4), H7 to H8 to H(1,2,3,4,5,6) to G to EF
ABCD to EFGH

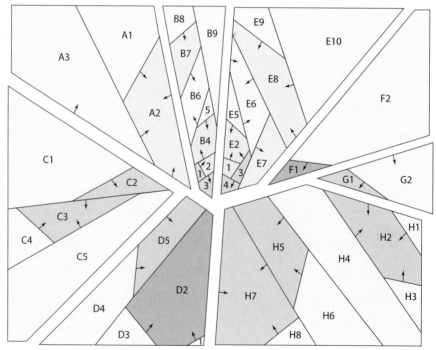

Iris, centered on a fall, straight seams, piecing diagram

Straight Seams

Symmetrical versions of Iris

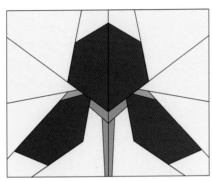

Simple symmetrical iris, straight seams, rectangular block, centered on a standard

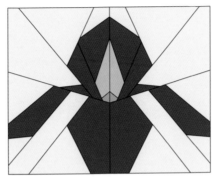

Simple symmetrical iris, straight seams, rectangular block, centered on a fall

Iris, symmetrical rectangular blocks quilt design

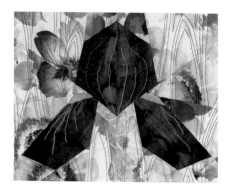

This iris block is designed within a rectangle, and represents one half of the iris, when looking from the side of the flower. One block plus its reverse (mirror image) make a complete blossom.

Enlarge the pattern to 219%.

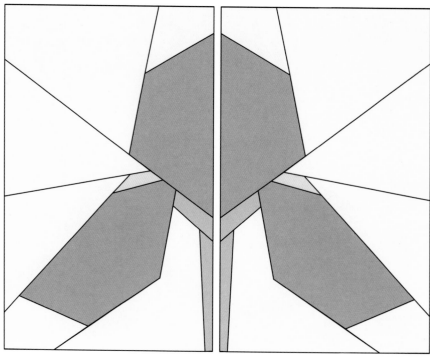

Iris, symmetrical, block pattern
Rectangular block makes one-half iris, centered on a standard

Sew:
A1 to A2 to A3
AR1 to AR2 to AR3
B1 to B2 to B3 to B4 to B5 to B6
BR1 to BR2 to BR3 to BR4 to BR5 to BR6
C1 to C2 to C3 to B to A
CR1 to CR2 to CR3 to BR to AR
ABC to ARBRCR

Iris, symmetrical rectangular block, piecing diagram

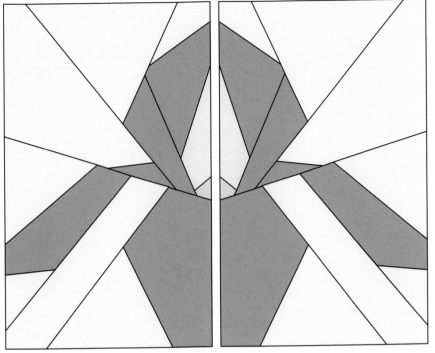

Iris, symmetrical, block pattern
Rectangular block makes one-half iris, centered on a fall

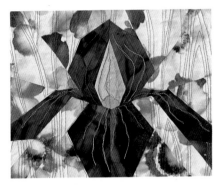

The simplest iris is pieced symmetrically with straight seams. I've pieced the blocks (half of an iris) at 8 by 5 inches (about 13 by 20 cm) making each iris a 10 by 8 inch rectangle. Enlarge the pattern 219%.

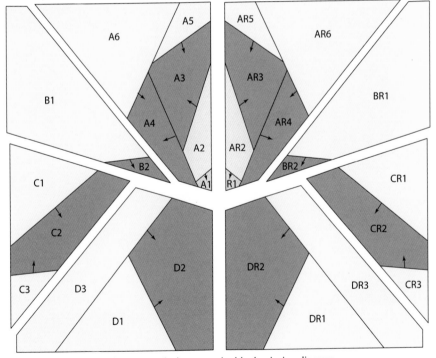

Iris, symmetrical rectangular block, piecing diagram

Sew:
A1 to A2 to A3 to A4 to A5 to A6
AR1 to AR2 to AR3 to AR4 to AR5 to AR6
B1 to B2 to A
BR1 to BR2 to AR
C1 to C2 to C3
CR1 to CR2 to CR3
D1 to D2 to D3 to C to AB
DR1 to DR2 to DR3 to CR to ARBR
ABCD to ARBRCRDR

Morning Glory

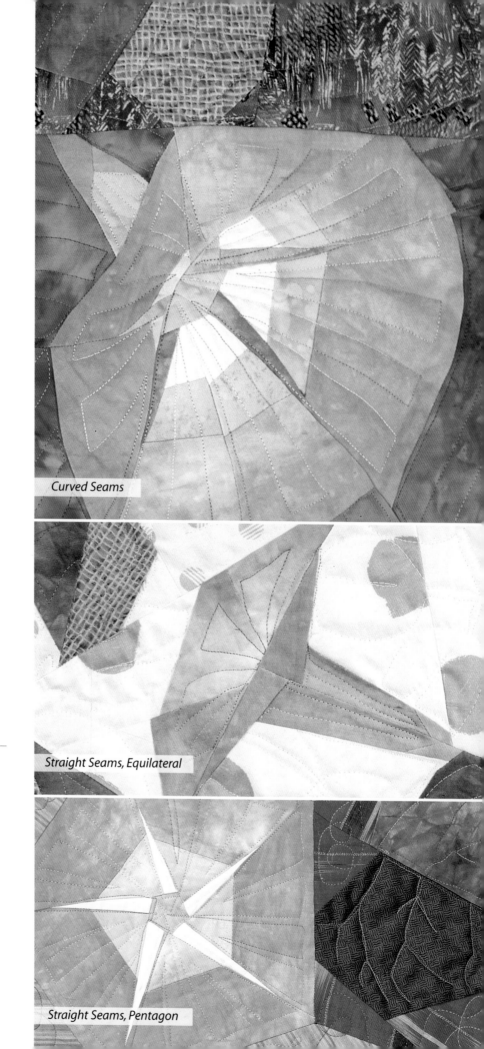

Curved Seams

Straight Seams, Equilateral

Straight Seams, Pentagon

The trumpet-shaped flowers of morning glories, usually blue or rose, shade to white and slightly yellow in their centers. The twining annual vine, with its tendrils, furled umbrella-like buds, and simple leaves is one of my favorite "climbers" for fences and walls.

Curved Seams

A curved-seam version of Morning Glory

Morning Glory, curved seams,
square block

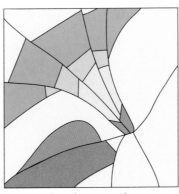

Morning Glory, curved seams,
square block

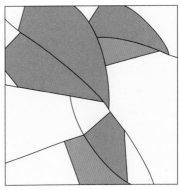

Morning Glory leaf, curved seams,
square block

Here is a design for a Morning Glory quilt with traditional square blocks. In this case, I use both gentle curves in the piecing and straight lines. Refer to the Appendix, page 109, for instructions on sewing curves.

Because squares have four equal sides, the blocks can be turned randomly to make a more natural looking design. You might add vines and tendrils to this pattern with quilting stitches. The background can also be colored to make other variations.

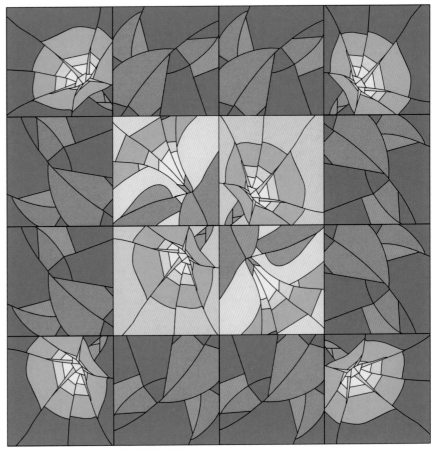

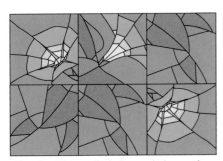

Morning Glory quilt design, variation setting

Morning Glory quilt design with a four-patch color scheme
6 flower blocks, 2 side-view flower blocks, 8 leaf blocks

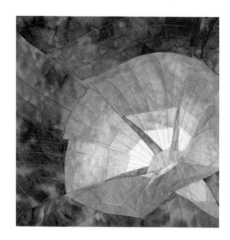

I've sewn this block at 9 ½ by 9 ½ inches (about 24 by 24 cm). Enlarge this pattern to 211%.

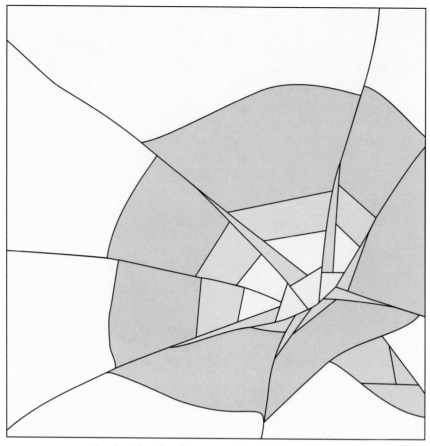

Morning Glory face flower, curved seams, block pattern

Sew:
A1 to A2 to A3 to A4 to A5 to A6
B1 to B2 to B3 to B4 to B5 to B6
C1 to C2 to C3
D1 to D2 to D3 to D4 to D5 to D6 to D7 to D8
E1 to E2 to E3 to D to C
F1 toF2 to F3 to F4
F5 to F6 to F7 to F8 to F9 to F(1,2,3,4) to F10
 to A to B
FAB to EDC

Parts of some of the sections may be foundation pieced.

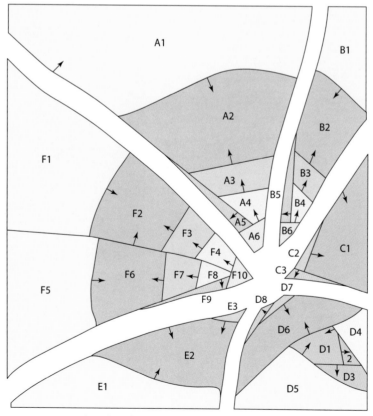

Morning Glory face flower, square block, piecing diagram

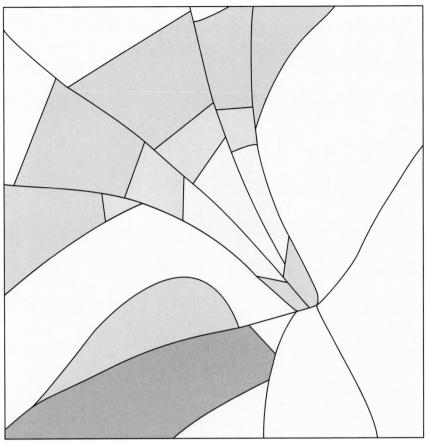

Morning Glory side flower, curved seams, block pattern

A second square block contains a side flower and single leaf.

Enlarge this pattern 211% to about 9 1/2" square (24 cm).

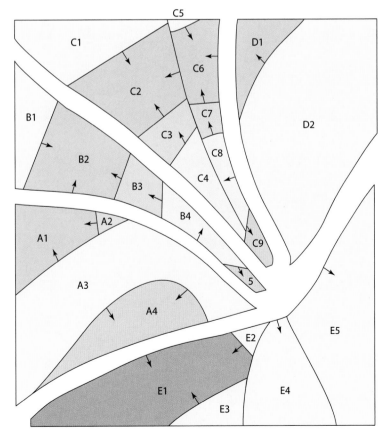

Morning Glory side flower, square block, curved seams, piecing diagram

Sew:
A1 to A2 to A3 to A4
B1 to B2 to B3 to B4 to B5
C1 to C2 to C3 to C4
C5 to C6 to C7 to C8 to C(1,2,3,4) to C9
D1 to D2
E1 to E2 to E3 to E4 to E5
A to B to C to D to E

Parts of some of the sections may be foundation pieced.

Enlarge this pattern 211% to about 9½" square (24 cm).

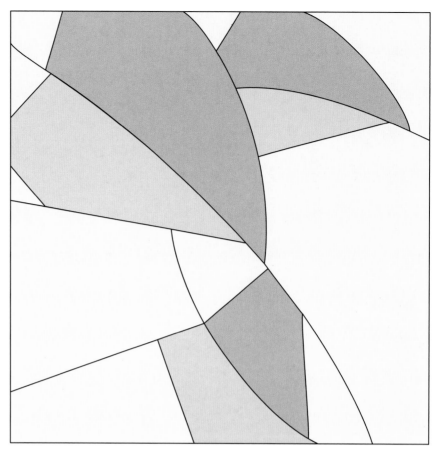

Morning Glory leaves, curved and straight seams, block pattern

Sew:
A1 to A2
B1 to B2 to B3
C1 to C2
D1 to D2 to D3
E1 to E2 to E3
F1 to F2 to F3
B to C to A
E to D to F
ABC to DEF

FOUNDATION (PAPER) PIECING: All sections except B, which has a curved seam could be sewn as foundation pieced sections. [B1 and B2 could be foundation pieced as well, with B3 added separately.] If so you will lose some of the sculptural quality of the template pieced block that can be built in with a careful choice of pressing direction of the seam allowances.

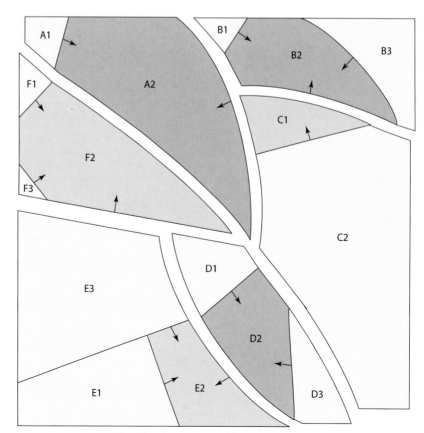

Morning Glory leaves, square block, piecing diagram

Straight Seams

An equilateral triangle version of Morning Glory

Morning glory face flower and leaf, straight seams, equilateral triangle block

Morning glory side flower and leaf, straight seams, equilateral triangle block

Morning glory bud and leaves, straight seams, equilateral triangle block

This set of morning glory designs uses equilateral triangles as the block shapes. These are pieced with straight seams.

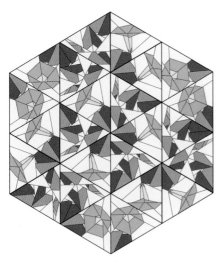

Morning Glory quilt, symmetrical setting design

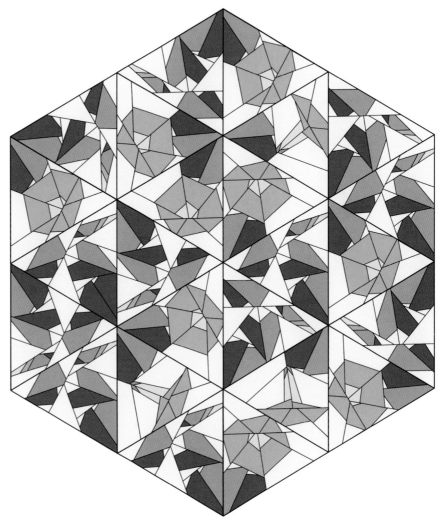

Morning Glory quilt, random setting design

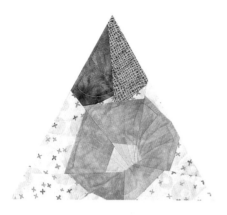

I've sewn these blocks as triangles 11½ inch (29 cm) on a side. Enlarge this pattern to 252%.

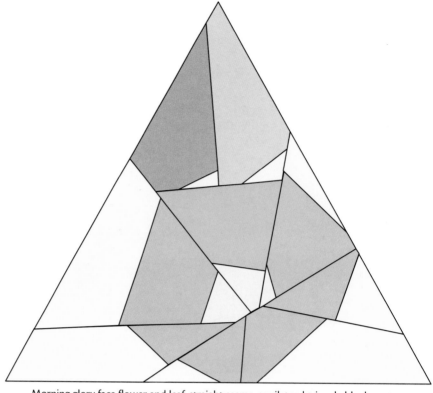

Morning glory face flower and leaf, straight seams, equilateral triangle block pattern

Sew:
A1 to A2, A3 to A4 to A5 to A(1,2)
B1 to B2
C1 to C2 to C3 to C4
D1 to D2 to D3
E1 to E2 to E3 to E4, E5 to E6 to E(1,2,3,4)
B to C to A to D to E

Because these 3 blocks are straight seams with lower case y intersections they may be chain-pieced through the machine.

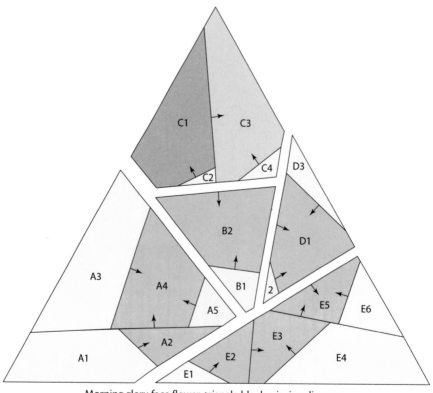

Morning glory face flower, triangle block, piecing diagram

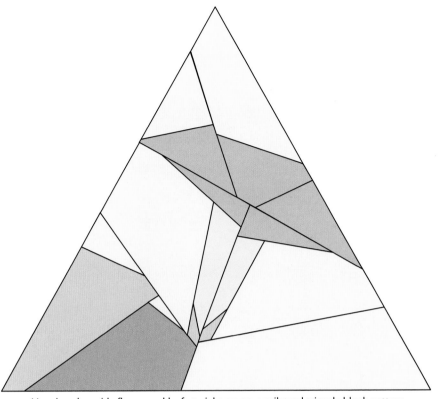

Morning glory side flower and leaf, straight seams, equilateral triangle block pattern

Enlarge this pattern 252% to about 11 ½ inches (29 cm) on a side.

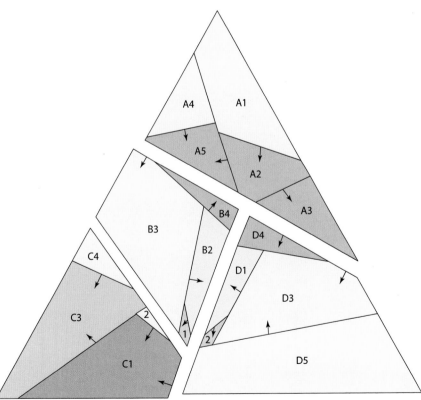

Morning glory side flower, triangle block, piecing diagram

Sew:
A1 to A2 to A3, A4 to A5 to A(1,2,3)
B1 to B2 to B3 to B4
C1 to C2 to C3 to C4
D1 to D2 to D3 to D4 to D5
B to C to D to A

Variation to add detail to center of flower:
Add 3 small pale pieces to A2, A3, A5 by subdividing templates or sew-and-flip.

Press the seam allowances under the flowers and leaves to raise them from the surface. Notice that I have kept the piecing seams within the blocks away from the block corners for ease in joining the blocks together.

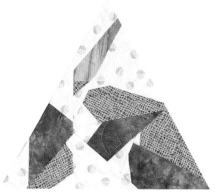

Enlarge this pattern 252% to about
11½ inches (29 cm) on a side.

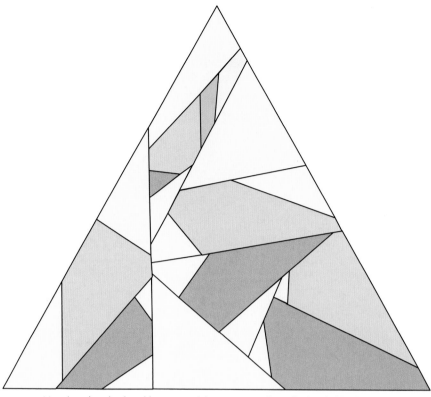

Morning glory bud and leaves, straight seams, equilateral triangle block pattern

Sew:
A1 to A2 to A3 to A4 to A5 to A6
B1 to B2 to B3 to B4
C1 to C2
D1 to D2 to D3 to D4 to D5
F1 to F2 to F3, F4 to F5 to F6 to F(1,2,3)
A to B, C to D, AB to CD to E to F

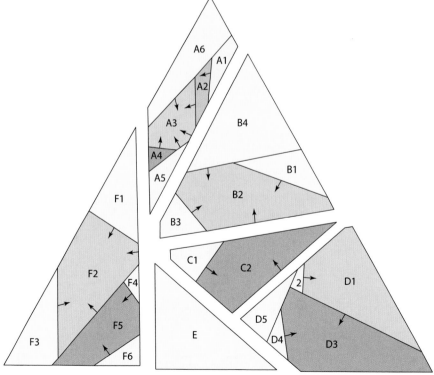

Morning glory bud and leaves, triangle block, piecing diagram

Straight Seams

A pentagon version of Morning Glory

Morning glory, straight seams,
pentagon block

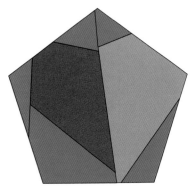

Morning glory leaf, straight seams,
pentagon block

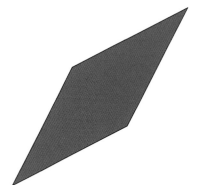

Morning glory
background diamond

The choice of pentagon-shaped blocks is an unusual and interesting one. In this sketch, you will see that pentagons don't tessellate (fit together by themselves to cover a surface with no holes and no overlaps), but they can do so with the addition of a diamond shape. The sides of the diamond are the same length as the sides of the pentagon. The interior angles of the diamond are 36° and 144°.

The pentagon/diamond blocks will leave an odd-shape outside edge. To produce a rectangular quilt, either appliqué (or inset-corner piece) the irregular outside edge to a background. Or sew enough pentagon/diamond blocks to extend past the edge of the rectangle and trim them off with a rotary cutter.

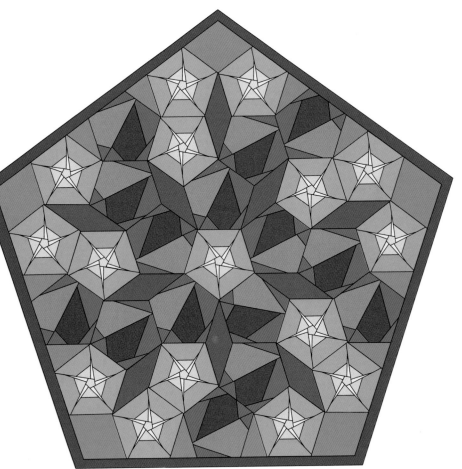

Morning glory quilt design with the addition of plain
background diamonds

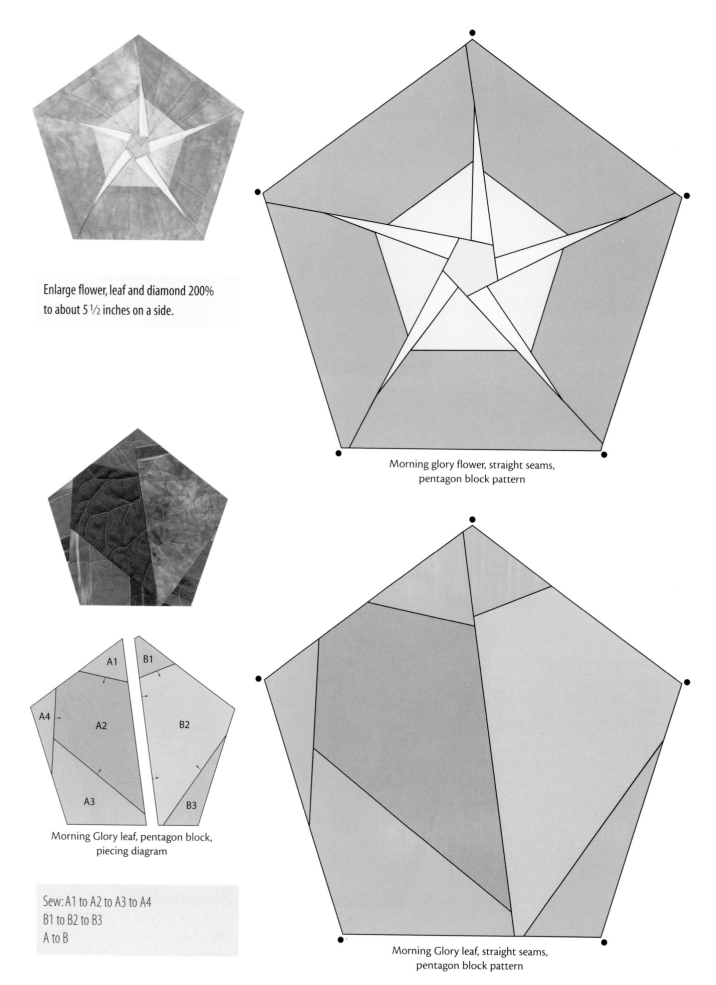

Enlarge flower, leaf and diamond 200% to about 5 ½ inches on a side.

Morning glory flower, straight seams, pentagon block pattern

A1

B1

A4

A2

B2

A3

B3

Morning Glory leaf, pentagon block, piecing diagram

Sew: A1 to A2 to A3 to A4
B1 to B2 to B3
A to B

Morning Glory leaf, straight seams, pentagon block pattern

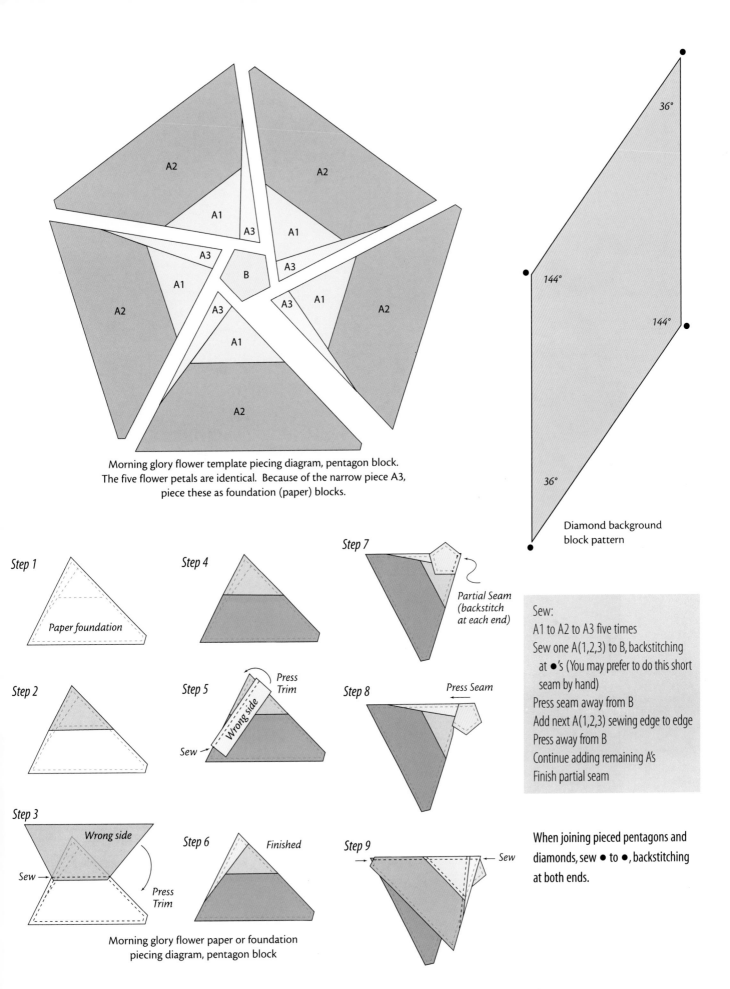

Morning glory flower template piecing diagram, pentagon block. The five flower petals are identical. Because of the narrow piece A3, piece these as foundation (paper) blocks.

Diamond background block pattern

Step 1

Paper foundation

Step 2

Step 3

Wrong side

Sew

Press Trim

Morning glory flower paper or foundation piecing diagram, pentagon block

Step 4

Step 5

Press Trim

Wrong side

Sew

Step 6

Finished

Step 7

Partial Seam (backstitch at each end)

Step 8

Press Seam

Step 9

Sew

Sew

Sew:
A1 to A2 to A3 five times
Sew one A(1,2,3) to B, backstitching at ●'s (You may prefer to do this short seam by hand)
Press seam away from B
Add next A(1,2,3) sewing edge to edge
Press away from B
Continue adding remaining A's
Finish partial seam

When joining pieced pentagons and diamonds, sew ● to ●, backstitching at both ends.

Rose

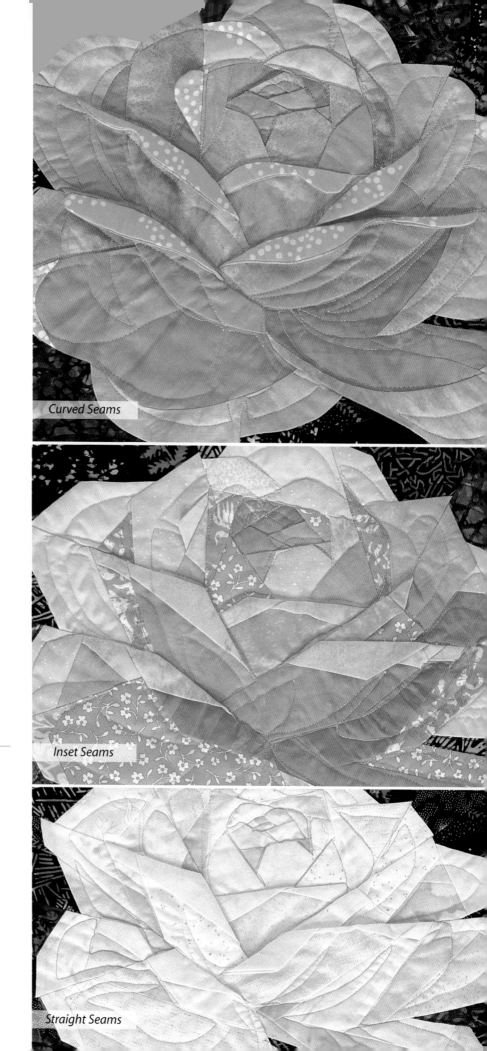

Curved Seams

Inset Seams

Straight Seams

A single wild rose is a five-part flower. Most modern roses are hybrids, either double or semi-double, with many layers of many petals. Piecing a wild rose of five petals is a simple process because the structure of the flower is clear.

Curved Seams

A curved-seam version of Rose

Rose, curved seams, faced flaps

As the number of petals increase, the process of developing a piecing design becomes more difficult. For my rose blocks for this book, I decided to use a log cabin style area to start the center of a more elaborately pieced block.

I planned insertions of folded or faced narrow flaps to add rolled edges to some of the petals. I chose a semi-double rose to work with and prepared this design with curved seams.

I have sewn this rose to make a 10 by 13 1/2 inch (about 25 by 34 cm) rectangle. Because of the curved seams, the piecing will proceed slowly. Again, you could enlarge this design further to make the curved seam piecing somewhat easier and to create a fine wallhanging or quilt. Enlarge this diagram 193%.

Rose, curved seams, faced flaps, rectangular block pattern

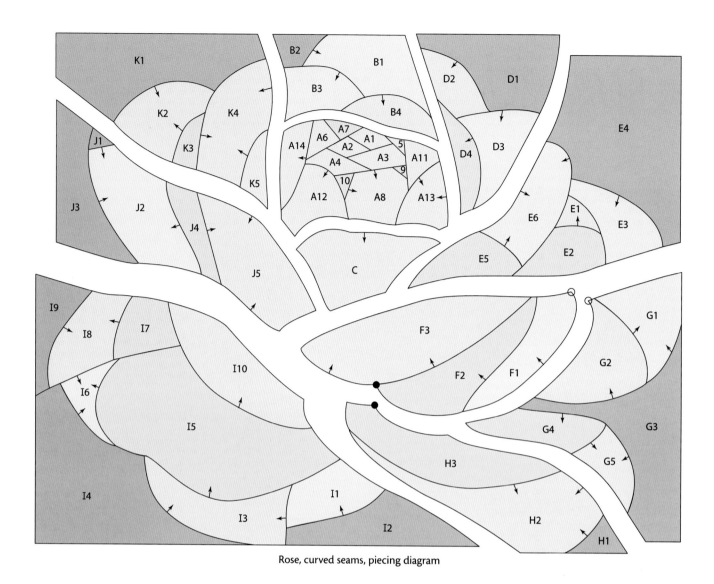

Rose, curved seams, piecing diagram

Sew:
 A1 to A2 to A3 to A4 to A5 (can be
 foundation pieced)
A6 to A7 to A(1,2,3,4,5)
A8 to A9 to A10 to A(1,2,3,4,5,6,7) to A11
 to A12 to A13 to A14
B1 to B2 to B3 to B4 to A
D1 to D2 to D3 to D4 to AB
E1 to E2 to E3 to E4, E5 to E6 to E(1,2,3,4)
F1 to F2 to F3, backstitching at ●
G1 to G2 to G3, G4 to G5 to G(1,2,3)

H1 to H2 to H3 to G
F to GH from ○ to ●, backstitching at ●
I1 to I2 to I3 to I4, I5 to I6 to I (1,2,3,4)
I7 to I8 to I9 to I(1,2,3,4,5,6) to I10
Sew I to H
J1 to J2 to J3 to J4 to J5
K1 to K2 to K3 to K4 to K5

Once these sections are pieced, you will
be ready to add the faced flaps.

Notice that this curved seam block (above)
requires careful piecing when joining sections
F, G, and H.

The shaded areas on the diagram (right) are
faced flaps caught in the seaming and loose
on one edge.

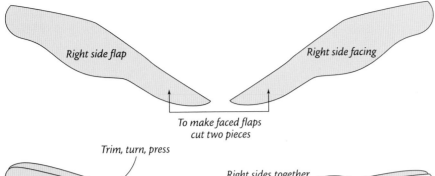

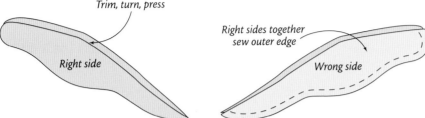

Right side flap

Right side facing

To make faced flaps
cut two pieces

Trim, turn, press

Right side

*Right sides together
sew outer edge*

Wrong side

Preparing the faced flaps

Cut two pieces for each flap. one face up and one reversed, They may be cut from different fabrics if desired. With right sides together, sew the outer curved edges. Trim, clip if necessary, and turn right side out. Press.

If you choose to make this rose at a very large size, you might consider using a lightweight interfacing or batting when making the faced flaps for additional dimension. If you use different fabrics on the flap and its facing, you might roll out the facing a bit with a steam iron to make a sliver the facing color show on the right side of the flap. See Appendix for more discussion about flaps.

Pin or baste the flaps to the petal pieces of sections C, E, F, I, J, and K before continuing with the construction.

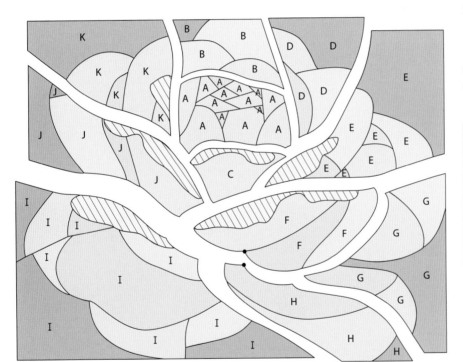

Pinning or Basting the flaps to the petal pieces

Sew:
C to ABD
E to ABCD
K to ABCDE
ABCDEK to J
FG to ABCDEJK
HI to ABCDEFGJK backstitching at ●

Now, proceed with the piecing, treating the petals and their flaps as one in joining the pieces together.

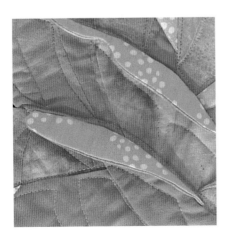

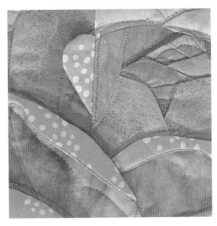

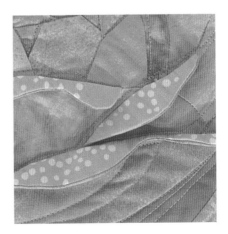

Inset Corner Seams

An inset-seam version of Rose

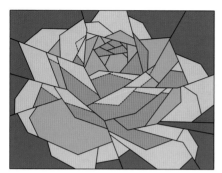

Rose, inset corner seams, folded flaps

For a second rose, I've planned a design using inset corner seams.* Again I've added flaps for dimension. On this rose, the flaps are folded, rather than sewn with a facing.

* See Appendix on page 109.

I have sewn this rose as a 10 by 13 1/2 inch (about 25 by 34 cm) rectangle. Enlarge this diagram 193%. It could also be made larger than this for a dramatic wallhanging.

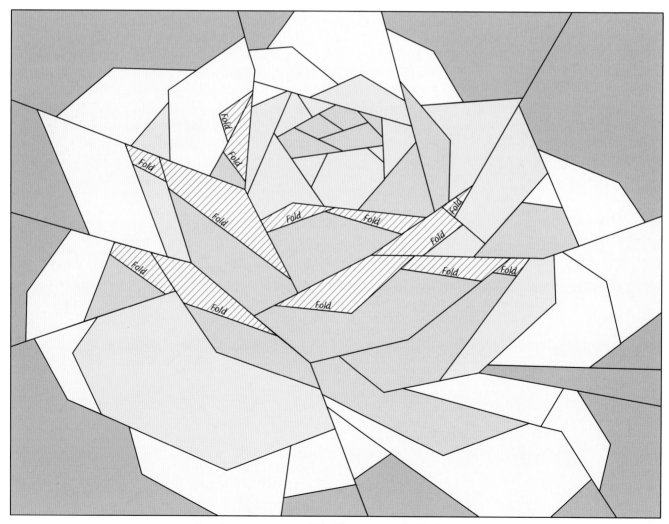

Rose, inset corner seams, folded flaps, rectangular block pattern

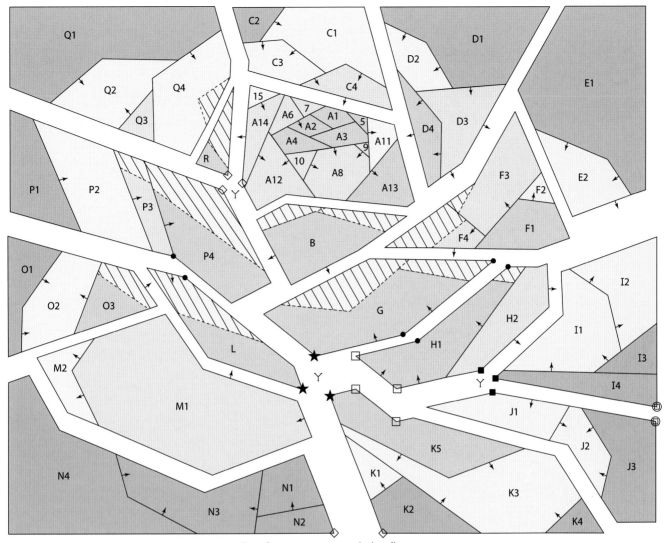

Rose, inset corner seams piecing diagram

Notice that this design includes a few Y (Upper Case Y) seams when joining the sections together. I recommend sewing these intersections by backstitching at the corners, rather than continuing the stitching through the seam allowances. Refer to the Appendix, page 109.

Press the seam allowances in the directions of the small arrows to sculpture the surface.

Pin or baste the folded flaps to B, F3, F4, G, H1, L, P3, P4, O4, Q4, and R before beginning the piecing. To add flaps see detail diagram on page 94.

Sew:
A1 to A2 to A3 to A4 to A5 (this can be done on a foundation if desired)
A6 to A7 to A(1,2,3,4,5)
A8 to A9 to A10 to A(1,2,3,4,5,6,7) to A11 to A12 to A13
A14 to A15 to A(1,2,3,4,5,6,7,8,9,10,11,12,13)
A to B (inset corner seam)
C1 to C2 to C3 (inset) to C4 (inset) to AB
D1 to D2 (inset) to D3 to D4 (inset) to ABC
E1 to E2 (inset)
F1 to F2, F3 to F4 to F(1,2) to E
H1 to H2
I1 to I2 (inset) to I3 to I4 to H (inset) backstitching at ■ to G from ● to ●
EF to GHI (inset)

J1 to J2 to J3 (inset)
K1 to K2 to K3 to K4 to K5 (inset) to J (inset)
HI to JK □ to □ to ■, backstitching at ■ (Y seam); ■ to ◔, backstitching at ■ (Y seam)
M1 to M2 (inset)
N1 to N2 to N3 to N4 (inset) to M (inset)
O1 to O2 (inset) to O3 to NM to L (inset)
G to HK from ● to ★, backstitching at ★
LMN to K from ★ to ◇, backstitching at ★
Q1 to Q2 (inset) to Q3 to Q4 (inset) to R
QR to CA, backstitching at ◇ (Y seam)
P1 to P2 to P3 to P4 backstitching at ●
P to AB, backstitching at ◇ (Y seam)
ABCDPQR to EFGH IJK
PG to OL from ★ to ● backstitching at both ends
P to OL, backstitching at ●

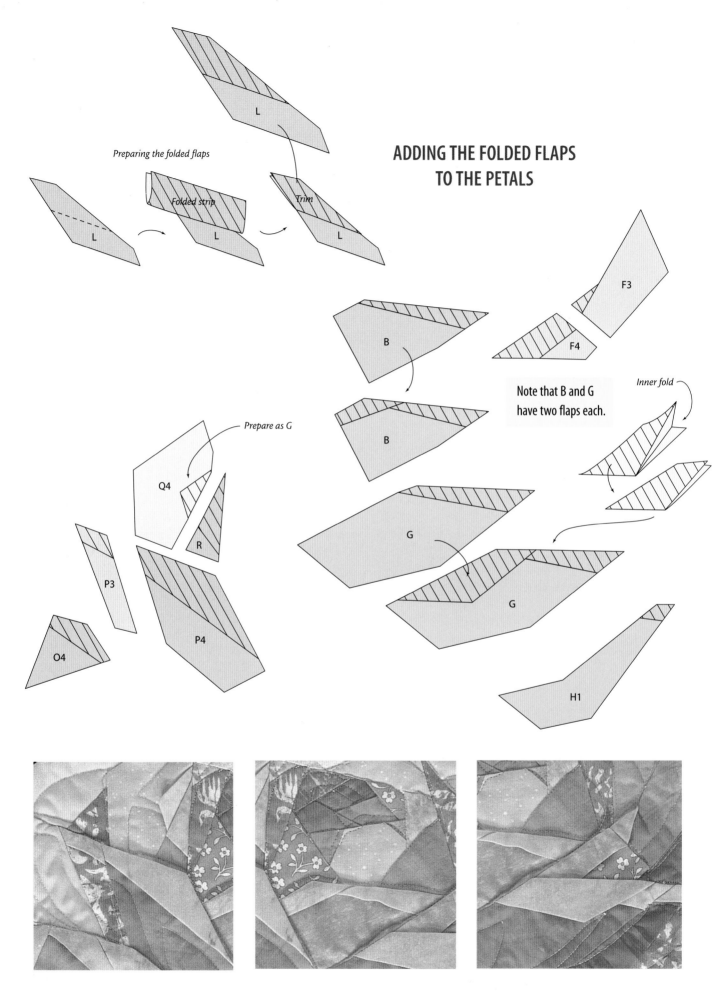

Preparing the folded flaps

Folded strip

Trim

**ADDING THE FOLDED FLAPS
TO THE PETALS**

Note that B and G
have two flaps each.

Inner fold

Prepare as G

Straight Seams
A straight-seam version of Rose

Rose, straight seams, folded flaps

For this rose, I have prepared a design with straight seams and all lower case y seams for ease in construction. There is no necessity for backstitching. Sew each seam from edge to edge.

I've added folded flaps (shaded) for dimension. I made this rose as a 10 by 13 ½ inch (about 25 by 34 cm) rectangle. Enlarge the pattern to 193%. This rose could also be sewn much larger as a dramatic wallhanging.

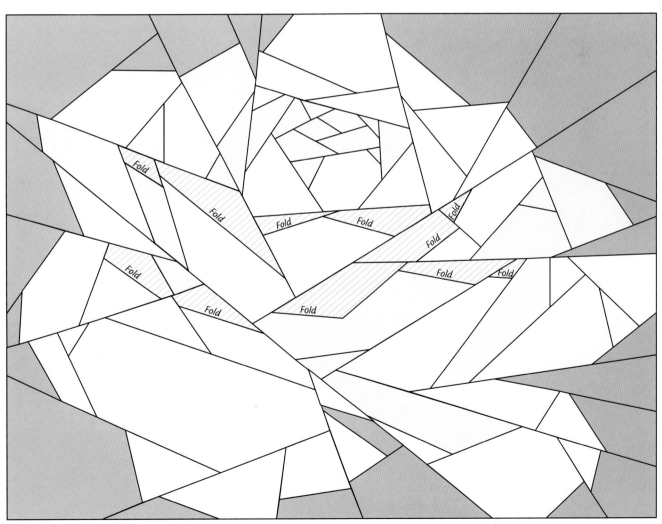

Rose, straight seams, folded flaps, rectangular block pattern

Pin or baste the folded flaps to petals A16, E1, E2, F1, G1, L4, M4, N1, N2 beginning the piecing. Treat the petals with flaps as one piece, include the raw edges of the flaps in the piecing seams.

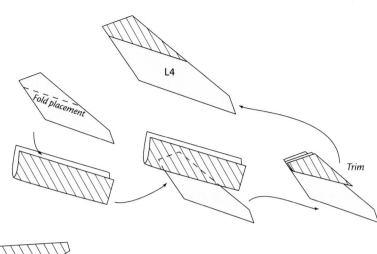

Fold placement

L4

Trim

N2

A16

A16

N1

Inner fold

Fold

Fold

Fold

Fold

M4

F1

Note that A16 and F1 have two flaps each.

PREPARING THE FOLDED FLAPS

F1

G1

E2

E1

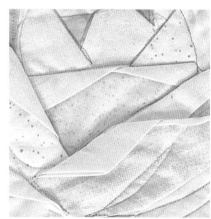
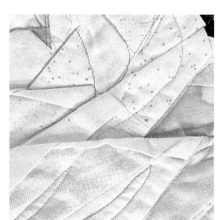

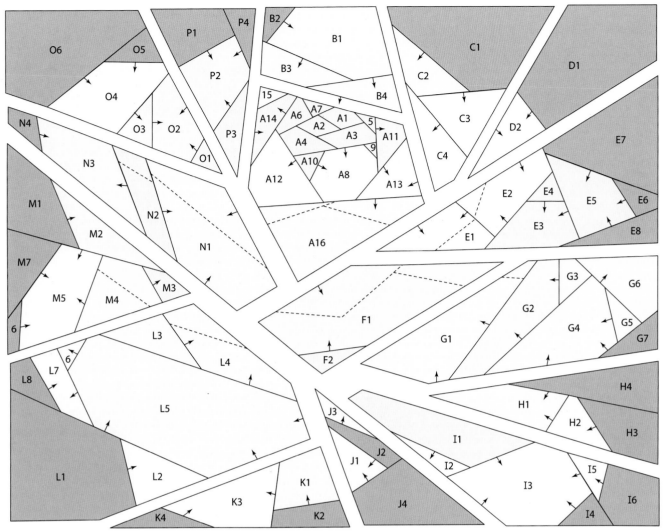

Rose, straight seams, piecing diagram

Press the seam allowances under the petals as indicated by the small arrows to sculpture the surface. I have enlarged this design to make a 10 by 13½ inch (about 25 by 34 cm) rectangular block for piecing purposes. It could be enlarged even more to make the sewing somewhat easier.

Sew:
A1 to A2 to A3 to A4 to A5 (can be foundation pieced)
A6 to A7 to A(1,2,3,4,5)
A8 to A9 to A10 to A(1,2,3,4,5,6,7) to A11 to A12 to A13 to A14 to A15
A16 to A(1,2,3,4,5,6,7,8,9,10,11,12,13,14,15), catching raw edges of folded flaps on A16
B1 to B2 to B3 to B4 to A
C1 to C2 to C3 to C4 to AB
D1 to D2 to ABC
P1 to P2 to P3 to P4 to ABCD
O1 to O2 to O3 to O4 to O5 to O6
N1 (with flap) to N2 (with flap) to N3 to N4 to O
NO to ABCDP
E1 (with flap) to E2 (with flap)
E3 to E4 to E(1,2)

E5 to E6 to E7 to E(1,2,3,4) to E8
G1 (with flap) to G2 to G3 to G4 to G5 to G6 to G7
H1 to H2 to H3 to H4 to G
I1 to I2 to I3 to I4, I5 to I6 to I(1,2,3,4)
I to GH
F1 (with flaps) to F2 to GHI to E
ABCDNOP to EFGHI
J1 to J2 to J3 to J4
K1 to K2 to K3 to K4
L1 to L2, L3 to L4 (with flap) to L5 to L6 to L7 to L8 to L(1,2)
K to L
M1 to M2, M3 to M4 (with flap) to M5 to M6 to M7 to M(1,2)
M to KL to J
JKLM to ABCDEFGHI NOP

Sweet Pea

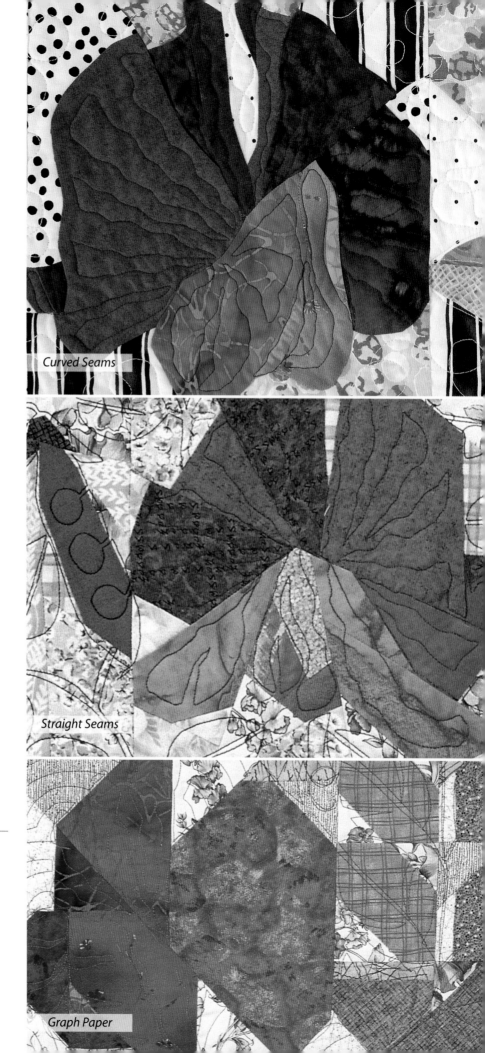

Curved Seams

Straight Seams

Graph Paper

The hooded flowers of sweet pea, including the paired leaves, pods, buds, and tendrils, make this an interesting plant to work with as a quilt design.

Curved Seams

A curved-seam version of Sweet Pea

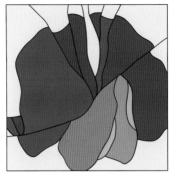

Sweet pea flower, curved seams

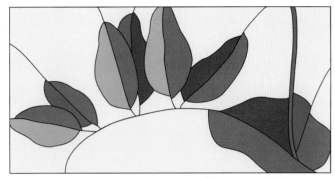

Sweet pea leaves, curved seams

This curved seam version of a sweet pea is graceful. Notice that when the blocks are arranged in the design to the right, the stems from the leaf blocks align with the flowers.

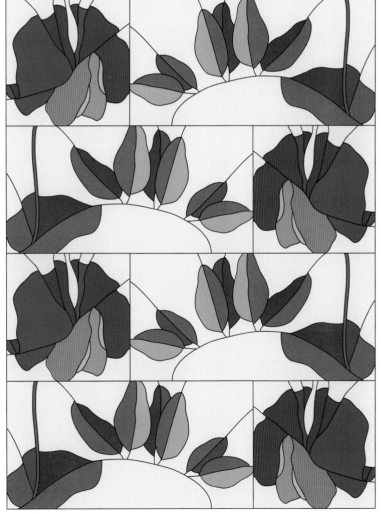

Sweet Pea, curved seams, quilt design

The flower fits in a square block, which I have enlarged to 9½ by 9½ inches (24 by 24 cm) for piecing purposes. Enlarge the pattern 208%.

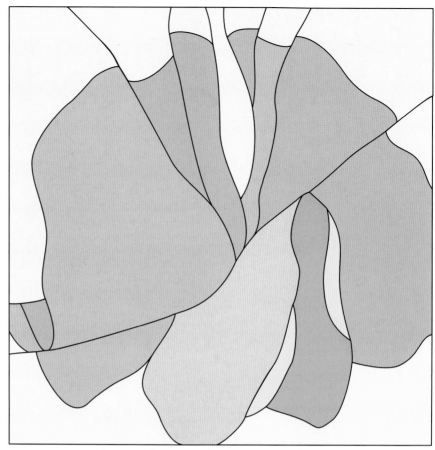

Sweet pea flower, curved seams, square block pattern

Sew:
A1 to A2 to A3 to A4 to A5
A6 to A7
A8 to A9 to A(6,7) to A(1,2,3,4,5)
B1 to B2
B3 to B4 to B(1,2)
B5 to B6 to B(1,2,3,4) to B7 to A
C1 to C2 to C3
D1 to D2 to D3
D4 to D5 to D(1,2,3) to D6 to C
AB to CD

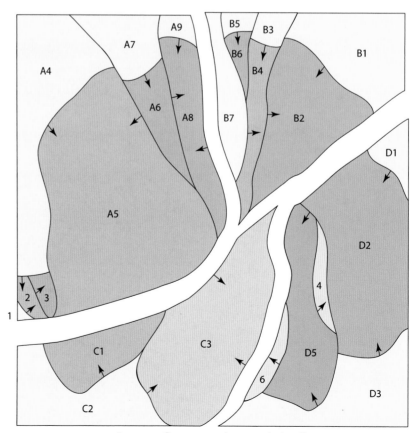

Sweet pea flower, curved seams, piecing diagram

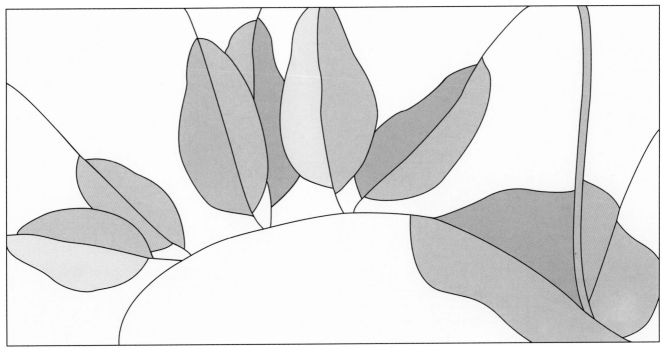

Sweet pea leaves, curved seams, rectangle block pattern

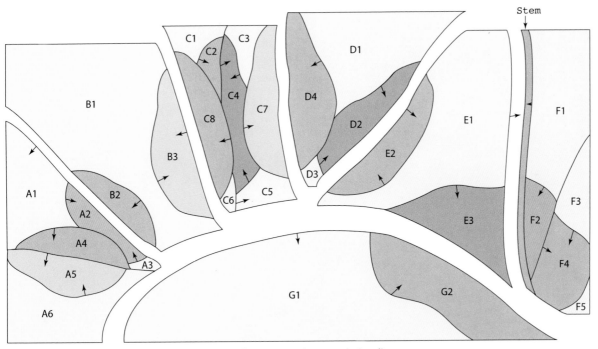

Sweet pea leaves, curved seams, piecing diagram

Within a rectangle of the same height, I've planned a branch of leaves and stem. The block has been enlarged to 9 ½ by 19 inches (24 by 48 cm) for ease of piecing. Enlarge the pattern 272%.

Sew: A1 to A2 to A3 to A4
A5 to A6 to A(1,2,3,4)
B1 to B2 to B3 to A
C1 to C2
C3 to C4 to C5 to C6 to C(1,2,) to C7 to C8 to AB

D1 to D2 to D3 to D4 to ABC
E1 to E2 to E3 to ABCD
F1 to F2
F3 to F4 to F5 to F(1,2) to STEM to ABCDE
G1 to G2 to ABCDEF

Straight Seams

Straight-seam versions of Sweet Pea

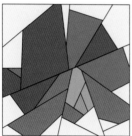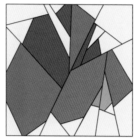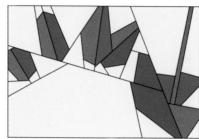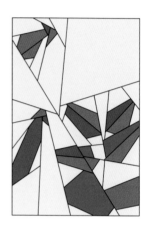

Sweet pea, straight seams, square and rectangular blocks

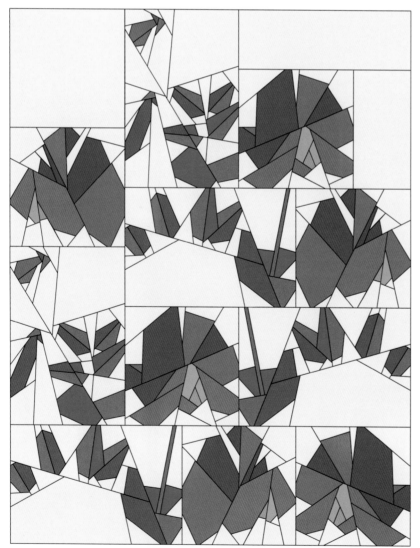

These blocks can be set together many ways by themselves or with the addition of plain rectangles of various sizes. Notice how the pieced stem from the leaf block can align with the flower blocks.

Sweet pea quilt design, matching stems and flowers

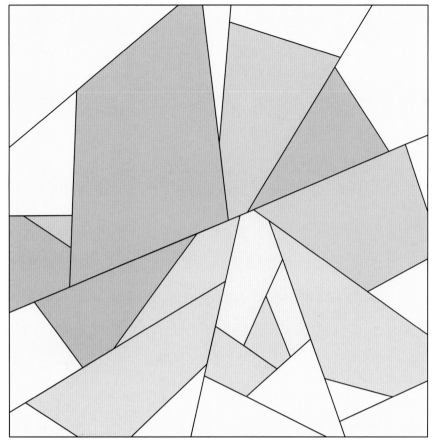

Face flower, straight seams, square block pattern

This version of a sweet pea quilt also uses square and rectangular blocks and straight seams, but this time many different angles are used in its design.

All of the piecing can be chained through the sewing machine with y intersections (lower case y's, see Appendix, page 109). I've enlarged the flower blocks to 9 inches by 9 inches (23 by 23 cm) for piecing. Enlarge the pattern 200%.

Sew:
A1 to A2 to A3 to A4 to A5
B1 to B2 to B3
B4 to B5 to B(1,2,3) to A
C1 to C2 toC3
C4 to C5 to C6 to C(1,2,3)
D1 to D2 to D3 to D4 to D5 to D6 to C
E1 to E2 to E3 to CD
F1 to F2 to F3 to CDE
AB to CDEF

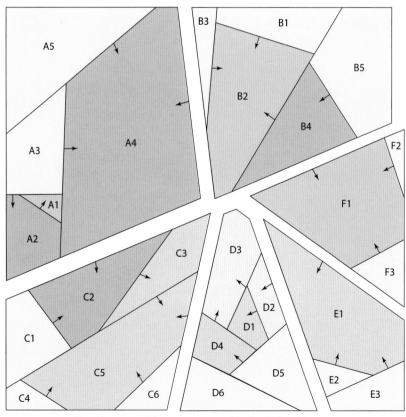

Face flower, straight seams, square block, piecing diagram

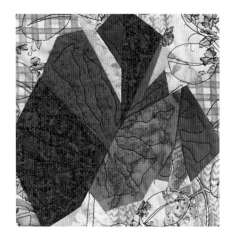

Enlarge the pattern to 200%.

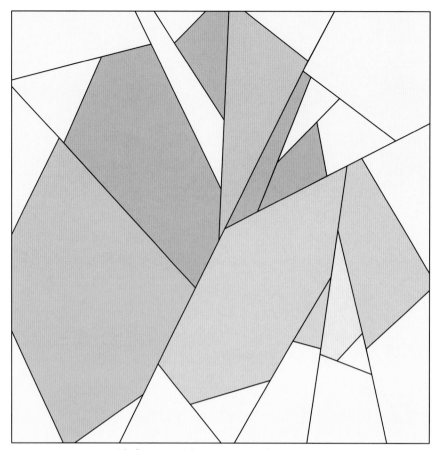

Side flower, straight seams, square block pattern

Sew:
A1 to A2
B1 to B2 to B3 to B4
B5 to B6 to B(1,2,3,4) to A
C1 to C2 to C3 to C4 to AB
D1 to D2 to D3
D4 to D5 to D(1,2,3)
E1 to E2 to E3;
E4 to E5 to E6 to E(1,2,3) to D
F1 to F2 to F3 to F4 to F5 to DE
ABC to DEF

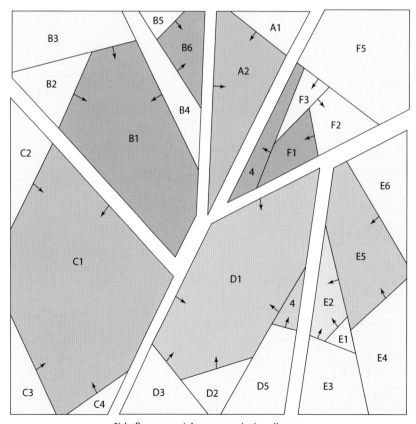

Side flower, straight seams, piecing diagram

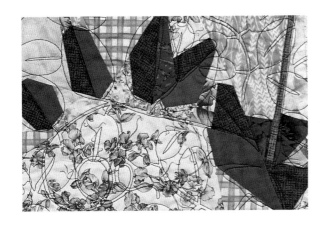

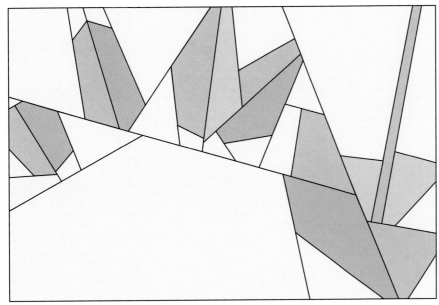

Leaf and stem, straight seams, rectangle block pattern

In a horizontal rectangle, I've developed a spray of leaves and stem. The block has been enlarged to 13 ½ by 9 inches (34 by 23 cm). Enlarge the pattern 296%.

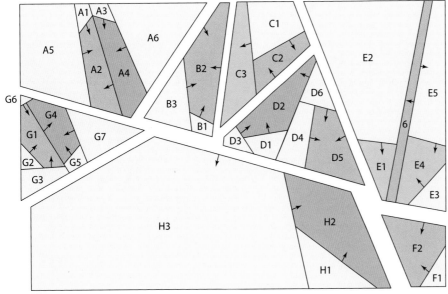

Leaf and stem, straight seams, piecing diagram

Sew:
A1 to A2
A3 to A4 to A(1,2) to A5 to A6
B1 to B2 to B3 to A
C1 to C2 to C3
D1 to D2 to D3
D4 to D5 to D6 to D(1,2,3) to C to AB
E1 to E2
E3 to E4 to E5 to E6 to E(1,2)
F1 to F2 to E
G1 to G2 to G3
G4 to G5 to G(1,2,3) to G6 to G7
H1 to H2 to H3 to G to ABCD to EF

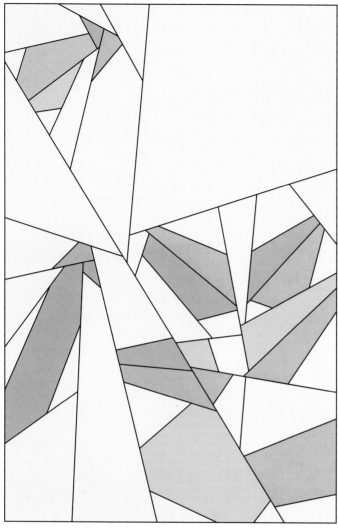

Bud and pod, straight seams, rectangle block pattern

Using a vertical rectangle of the same size as the leaf block, I've drawn a bud, pod, leaves, and space for tendrils.

Again, the block has been enlarged to 9 by 13½ inches (23 by 34 cm). Enlarge the pattern 251%.

Sew: A1 to A2 to A3 to A7
A4 to A5 to A6 to A(1,2,3)
A8 to A9 to A(1,2,3,4,5,6,7) to A10 to A11
C1 to C2 to C3 to C4 to C5 to C6
C7 to C8 to C(1,2,3,4,5,6)
D1 to D2 to D3 to D4 to D5 to D6 to D7 to D8
 to C to B to A
E1 to E2 to ABCD
F1 to F2 to F3 to F4 to F5 to ABCDE
H1 to H2 to H3 to H4 to H5 to H6 to H7
G1 to G2 to G3 to G4 to G5
G6 to G7 to G(1,2,3,4,5)
G8 to G9 to G(1,2,3,4,5,6,7) to H to I
ABCDEF to GHI

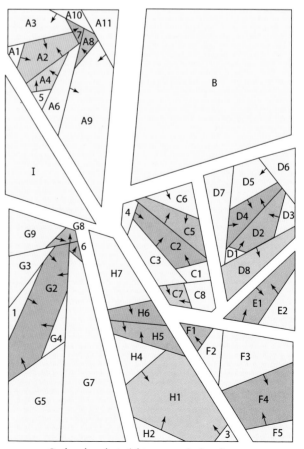

Bud and pod, straight seams, piecing diagram

Graph Paper

Graph-paper versions of Sweet Pea

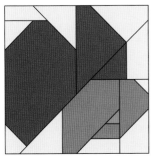

Sweet pea, side flower

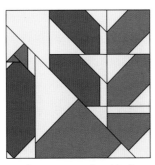

Sweet pea, pod and leaf

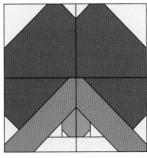

Sweet pea, face flower

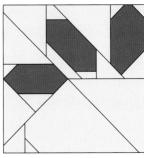

Sweet pea, small leaf

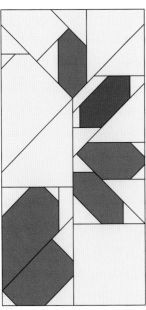

Sweet pea, large leaf

The "graph paper" style plans all of the blocks along the lines of graph paper or as true-bias seams. Most traditional blocks fall in this style as do Ruby McKim's flower blocks from the 1930s (Kaleidoscope and Sky Rocket are two exceptions). Graph-paper blocks produce many square, rectangular, and half-square triangle templates.

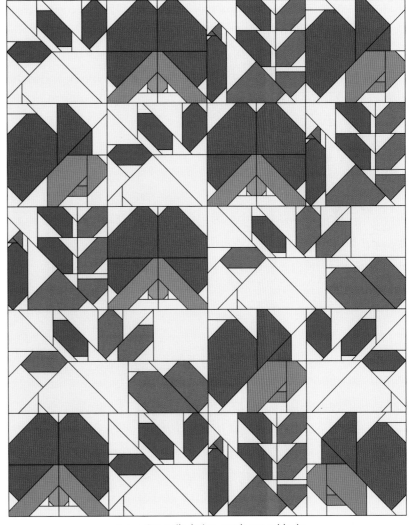

Sweet Pea quilt design, graph-paper blocks

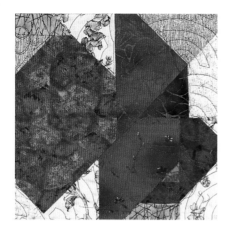

Enlarge the pattern 208%.

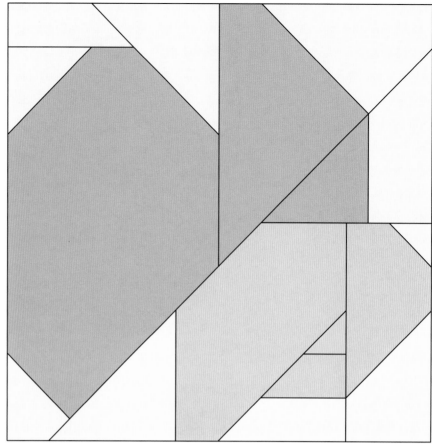

Sweet pea, side flower, graph paper, straight seams, square block pattern

Sew:
A1 to A2 to A3 to A4 to A5
B1 to B2 to A
C1 to C2 to C3 to C4 to C5
D1 to D2 to D3 to C
E1 to E2 to CD
AB to CDE

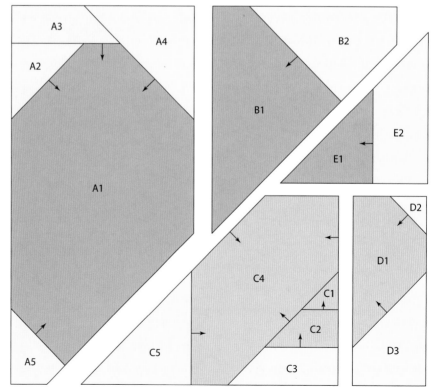

Sweet pea, side flower, piecing diagram

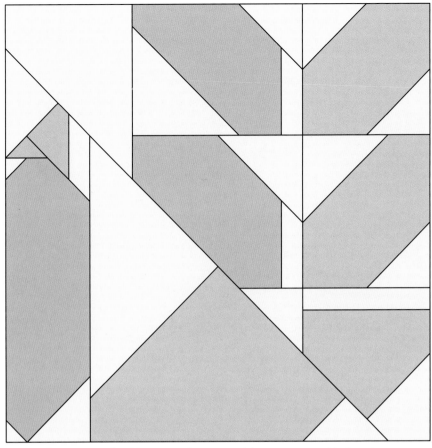

Sweet pea, pod and leaves, graph paper, straight seams, square block pattern

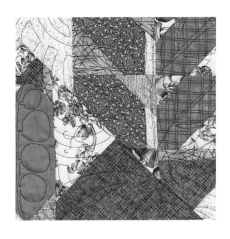

A version of a sweet pea square block with a pea pod and leaves and a straight (implied) stem which connects well under the side flower block.

I have enlarged the square blocks to 9½ inches on a side (24 cm). Enlarge the pattern 208%.

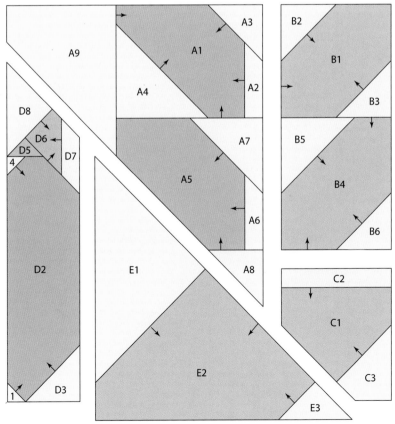

Sweet pea, pod and leaves, piecing diagram

Sew:
A1 to A2 to A3 to A4
A5 to A6 to A7 to A8 to A(1,2,3,4) to A9
B1 to B2 to B3
B4 to B5 to B6 to B(1,2,3,)
C1 to C2 to C3 to B to A
D1 to D2 to D3 to D4 to D5
D6 to D7 to D(1,2,3,4,5) to D8
E1 to E2 to E3 to D
ABC to DE

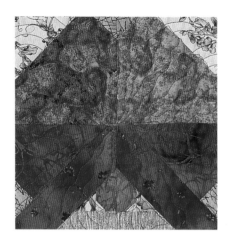

Enlarge the pattern 208% to 9½ inches (about 24 cm) on a side.

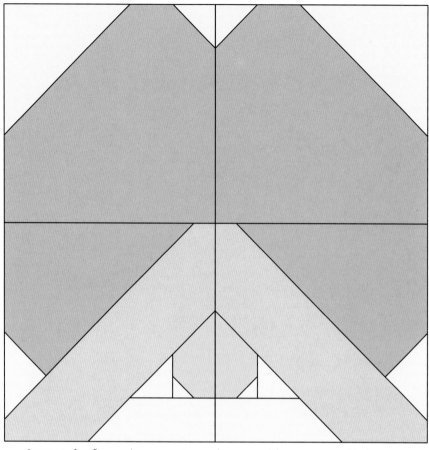

Sweet pea, face flower, mirror symmetry, graph paper, straight seams, square block pattern

Sew:
A1 to A2 to A3
B1 to B2 to B3 to B4 to B5
B6 to B7 to B(1,2,3,4,5)
A to B
AR1 to AR2 to AR3
BR1 to BR2 to BR3 to BR4 to BR5
BR6 to BR7 to BR(1,2,3,4,5)
AR to BR
AB to ARBR

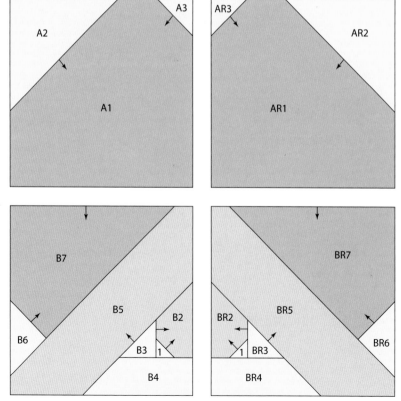

Sweet pea, face flower, piecing diagram

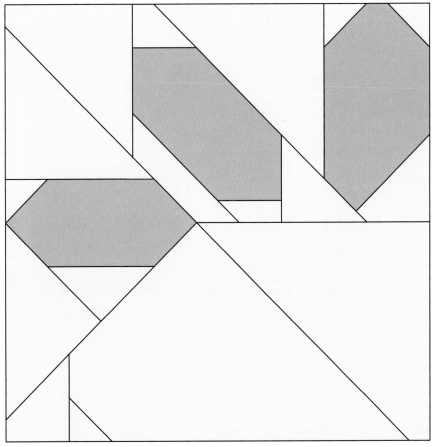

Sweet pea, small leaf, graph paper, straight seams, square block pattern

Sweet peas have a larger leaf that clasps the stem where it branches. I have planned two leaf blocks, piecing the leaves, and letting seamlines imply the stems. Tendrils can be drawn in with quilting lines.

Enlarge the pattern 208% to 9 ½ inches (about 24 cm) on a side.

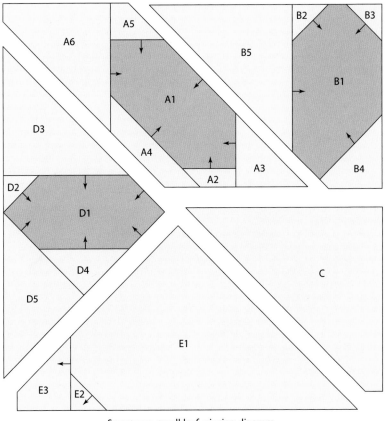

Sweet pea, small leaf, piecing diagram

Sew:
A1 to A2 to A3 to A4 to A5 to A6
B1 to B2 to B3 to B4 to B5 to A
C to AB
D1 to D2 to D3 to D4 to D5
E1 to E2 to E3 to D
ABC to DE

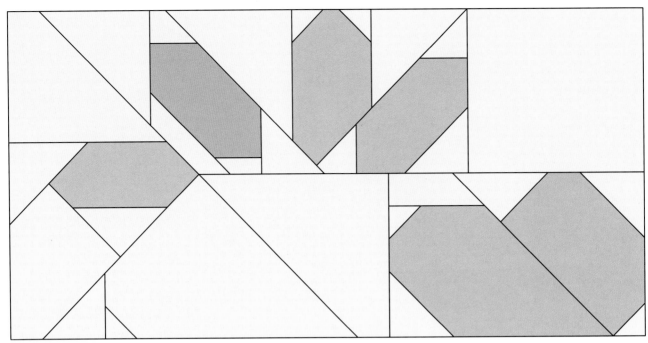

Sweet pea, large leaf, graph paper, straight seams, rectangular block pattern

Sew:
A1 to A2 to A3 to A4 to A5 to A6
B1 to B2 to B3 to B4 to B5
C1 to C2 to C3 to C4 to C5 to B to A
D1 to D2 to D3 to D4
D5 to D6 to D7 to D8 to D(1,2,3,4) to D9 to ABC
E1 to E2 to E3
F1 to F2 to F3 to F4 to F5 to E to ABCD

Enlarge the pattern 279% to 9 ½ by 19 inches (about 24 by 48 cm).

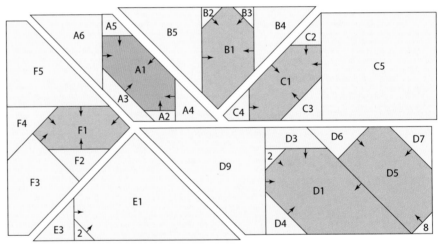

Sweet pea, large leaf, piecing diagram

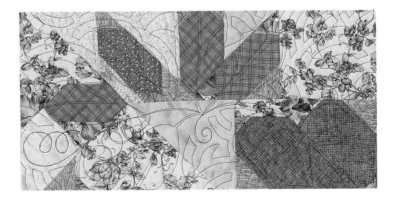

APPENDIX

This pattern book, *Pieced Flowers* is intended as a companion to *Piecing: Expanding the Basics*, where a variety of basic to complex piecing instructions are discussed in great detail. To assist the quiltmaker with piecing the patterns in *Pieced Flowers*, the following text is excerpted from *Piecing: Expanding the Basics*.

SEAMS

Piecing Curved Seams

Many quilters have developed individual techniques for handling curves. I assemble them by clipping the seam allowances on the concave piece. The depth and closeness of the clips will vary with the tightness of the radius of the curve. In the finished quilt the backing/batting/quilting stitches take the strain from the quilt seam.

Sewing a Gentle Curve

Pin together the endpoints of the two patches with the concave one on top. You may not have to pin the center points together or to clip the concave edge, depending on the radius of the curve and the flexibility of the fabric.

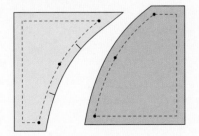

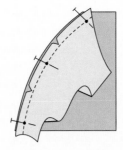

Sewing an "S" Curve

With "S" curves, part of the seam is concave on each piece. You may find this seam easier to manage if you sew it in two short sections, putting the piece with the concave edge on top while sewing each part of the seam. Placing piece A on top of B, sew from point 1 to point 2. Turn the unit over, then sew from point 3 to point 2.

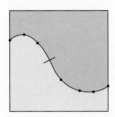

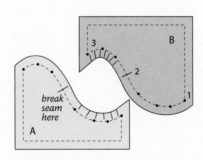

Practice several methods with varying radius curves. I prefer to pin and clip, clipping more closely, almost all the way to the seam line, for tight curves, and removing the pins as I get to them in the sewing process. Find a method that works for you and use it.

Piecing Inset Seams

When piecing a quilt, the quiltmaker can take some liberties, especially for wall quilts that will not get severe handling, that are more questionable than when sewing clothing.

When the quilt is finished and the quilting stitching done, the strain on the individual seams is distributed across the whole quilt. Save inset corners for closely woven fabrics, and use a smaller stitch length for the seam, clipping to the corner before you begin to sew. I find the inset technique useful in many of my designs because it allows me to eliminate some construction seams.

Insetting a Wide Angle

Clip the corner of the concave piece almost to the dot at point 2. Put piece A on top of piece B, right sides together, matching points 1 and 2, then carefully pinning them together. Starting at point 1, sew to point 2 and stop. Leaving the needle in the fabric, raise the presser foot, pull point 3 of piece A to match point 3 of piece B. Carefully pin the pieces together. Pivot both pieces on the needle, lower the presser foot, and complete sewing the seam.

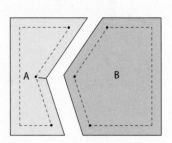

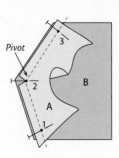

Piecing "Z" Seams

For a "Z" seam, place piece A on top of B and sew from points 1 to 2 to 3, then stop. Make a couple of small backstitches at 3. Remove the unit from the machine and turn it over. Match and pin point 4. Sew this last piece of seam, with B on the top, backstitching again at point 3.

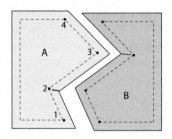

Piecing Puzzle Seams

You may have found this type of piecing in some traditional quilt blocks. It happens when a piece is locked into several others, making simple assembly impossible.

To sew this kind of construction, you will need to sew a partial seam, complete several other seams, and finally finish the partial seam to complete the block.

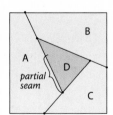

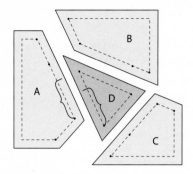

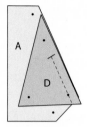

Starting at the edge, sew D to A stopping at the mark

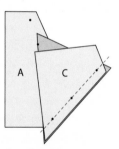

Sew C to AD

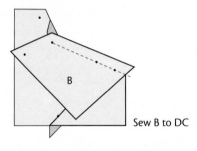

Sew B to DC

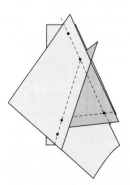

Finish sewing the partial seam

Piecing Y Seams

Joining three pieces of fabric together in traditional blocks can make two types of Y seam.

Piecing a "y" seam

In the first instance, piece B is sewn to piece A with a straight seam edge to edge. Then the AB piece is joined to piece C, again with a straight seam edge to edge. This is a simple construction to make and very easily machine pieced. This is a "y" seam (lowercase y).

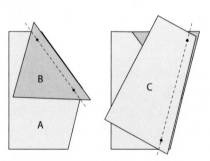

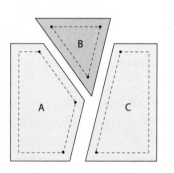

Piecing a "Y" Seam

Or you may begin with a diagram like this one, which we'll call a "Y" seam (uppercase Y).

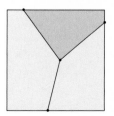

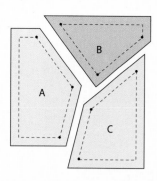

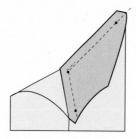

Here piece B is sewn to piece A with a small backstitch at the inner corner. Then piece C is joined to piece A, again with a small backstitch at the inner corner. Finally, piece B is sewn to piece C with a small backstitch at the inner corner.

The Y seam is simple if pieced by hand. With machine piecing this is a much more awkward construction than the first y seam.

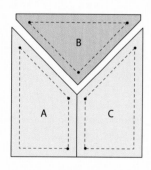

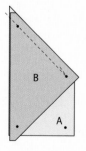

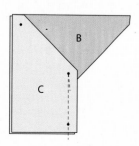

FLAPS

Piecing Flaps

You might choose to make a slightly three-dimensional shape, in this case a leaf, by making one or both sides as a flap, or a faced flap. The faced flaps are sewn first, before the block is assembled.

Making a Faced Flap

Cut two leaf halves, one right side up and one reversed, leaving $1/4$" seam allowances on all edges. With the leaf halves right sides together, sew the outer edge. This can be a simple smooth curve, a series of straight lines, or a more elaborate outline. Trim the seams and clip, if necessary. Turn the leaf right side out and press.

Lay the flap leaf on a piece of background fabric, matching the raw edges. Add the other half of the block, aligning the raw edges, and sew the seam through all layers. You can adjust the thickness of the flap by adding flannel, or batting, to the assembly

process. If you want quilting stitches on the flap, sew these while the flap is still loose, before it is sewn into the block.

The front and back of the leaf shape can be cut both from the same fabric, or you might use two different fabrics. While the flap is still loose, use a tailoring technique and iron to roll the outside seam edge slightly. A sliver of the backing will then show on the front, or a sliver of the front will show on the back.

FREEZER-PAPER TECHNIQUE

I trace the block (or entire quilt) onto the shiny side of freezer paper with a fine-line permanent marker. On the dull side of the paper I mark any tics or registration marks, and any labeling of the pieces so that they will be visible when the paper template is ironed onto the wrong side of the fabric. I use a highlighter to draw a line close to the edge of the block on the dull side as well. This tells me which edges are on the outside of the block and helps in the cutting and piecing process.

Be aware that the permanent marker line may transfer slightly from the shiny side of the freezer paper to the back of very light fabrics. If this bothers you, use a hard pencil rather than the permanent marker to trace the design. For large projects, tape the freezer paper sheets together on the dull side with masking tape (which won't melt on your iron).

Cut the freezer paper pieces apart as needed, place them shiny side down on the back of the selected fabric and iron them in place with a fairly hot iron. And then with the paper template stuck to the fabric, I cut the fabric piece, leaving a ¼" seam allowance outside the edge of the freezer paper. The

paper template sticks to the fabric very conveniently. It can be peeled off and reused several times if the fabric choice is changed. I cut the seam allowances by eye. You can measure them if you prefer.

For straight seam piecing, leave the freezer paper attached to the fabrics and sew along the edge of the paper after carefully matching and pinning the pieces. For curved seams or inset corner seams, trace around the edge of the freezer paper with a pencil that you can see (colored if necessary), which draws the seamline on the back of each fabric piece. Mark tics or register marks along the seam allowances. Remove the freezer paper.

ABOUT THE AUTHOR

Ruth B. McDowell is an internationally known professional quilt artist, teacher, lecturer, and author. She has made over 250 quilts in the last two decades, and her work is frequently seen in leading quilting and fiber arts magazines. Ruth resides in Winchester, Massachusetts.

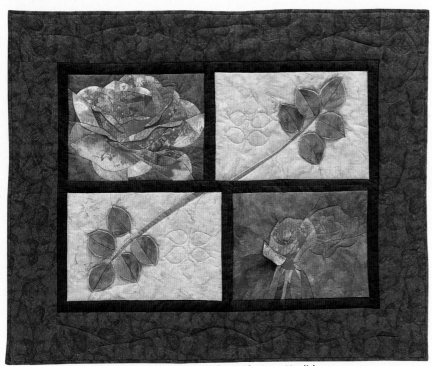

Ruth's Rose, 37" x 29", 1999 by Lynn Koolish

INDEX

Piecing
Expanding the Basics
Ruth's sought-after techniques for original pieced design. Includes curved seams, inset, multiple angles, Z seams, puzzle seams, and much more!

C&T Publishing, Inc.
P.O. Box 1456
Lafayette, CA 94549
(800) 284-1114
http://www.ctpub.com
email: ctinfo@ctpub.com